The Pre-Raphaelites

The Pre-Raphaelites

Trewin Copplestone

GRAMERCY

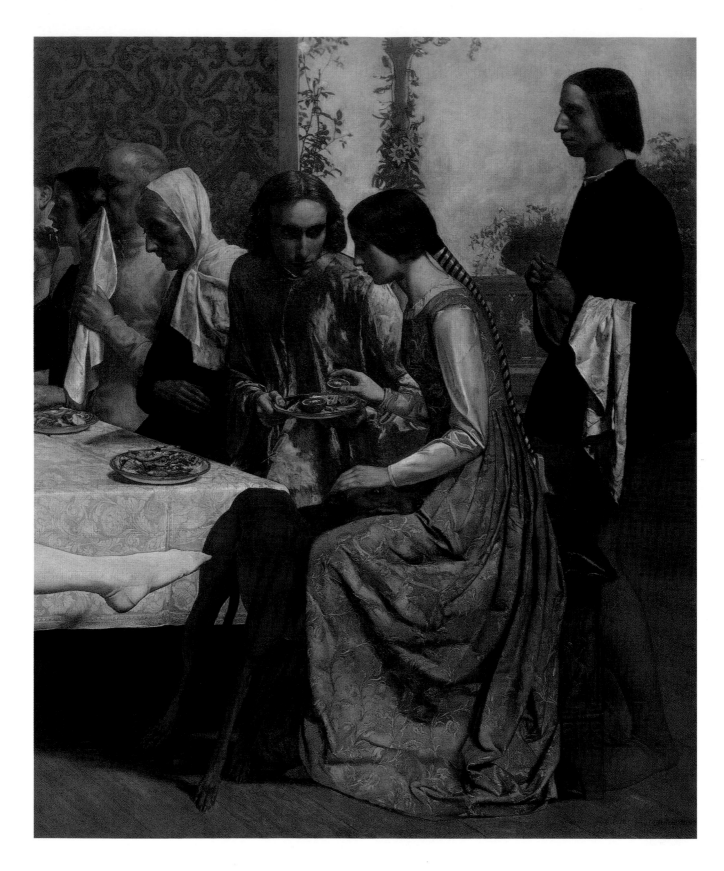

This 1999 edition is published by Gramercy Books™, an imprint of Random House Value Publishing, Inc., 201 East 50th Street, New York, NY 10022

Gramercy Books ™ and design are trademarks of Random House Value Publishing, Inc.

Random House New York • Toronto • London • Sydney • Auckland
http://www.randomhouse.com/

Printed in Singapore

ISBN 0-517-16116-8

10 987654321

List of Plates

PLATE 1

Beata Beatrix (1863)

Dante Gabriel Rossetti (1828–1882)

Oil on canvas, 34 x 26 inches (86.5 x 66cm)

The poet Dante was an important figure of influence and inspiration to the Rossetti family, and this work represents the death of Dante's Beatrice who sits, trance-like, while the messenger of death in the shape of a bird drops a poppy, the symbol of

remembrance, into her relaxing hands; a white poppy because Dante Gabriel Rossetti's wife, Elizabeth Siddal, died of an overdose of laudanum. The painting was also a memorial to her and Rossetti in a later letter wrote that 'the picture must of course not be viewed as a representation of the incident of the death of Beatrice but as an ideal of the subject, symbolized by a trance or sudden spiritual transfiguration'. In the background, on the right, Dante gazes across to the figure of Love on the left.

The Pre-Raphaelite Brotherhood, originally consisting of a secret group of seven young men, was formed in 1848 in London and lasted effectively for about five years. It was an artistic group of young student painters in the Royal Academy Schools and some of their friends, a very small part of the revolutionary spirit then motivating change throughout Europe at the point in history known as the Year of Revolutions. Following the French Revolution of 1789 and the domination of Europe by the Imperial ambition of Napoleon, 1848 heralded the overthrow of most European dynasties and a reformist spirit, inspired by a zeal for social justice introduced by the French Revolution, became a universal ambition in all European countries. It was, significantly, the year in which Karl Marx and Friedrich Engels wrote the Communist Manifesto, forecasting the fall of capitalism and the rise of a socialist society.

In Britain, where Marx had settled and lived for the remainder of his life, events were less dramatic and did not result in the overthrow of monarchy or government although the young Queen Victoria, who came to the throne in 1837, was not yet secure on her throne or as loved and revered by the populace as she later became. Nevertheless, there were disturbances arising from the repeal of the Corn Laws and the growth of a strong national public feeling for government reforms led by a group known as the Chartists, the nearest that Britain came to overt active revolutionaries. In April 1848, a great meeting was organized by them on Kennington Common in south London, which the Chartists hoped would provide evidence of the strong public desire for parliamentary and legal reform. In the event, the meeting was something of a fiasco but it did attract the interest of many young reformist enthusiasts, among them two young students from the Royal Academy Schools in central London who travelled on foot to the meeting.

It is important to emphasize the artistic revolution they

contemplated – without at that moment knowing what it should be. The movement that quickly originated from this youthful enthusiasm was one of the most significant in the formation of a new philosophy of painting that, despite the short life of the movement, actually did initiate changes that had a profound effect on British painting after the mid 19th century.

While for us in the 20th century the modern painting revolution is more often seen to have begun with Impressionism in France about 20 years later than the Pre-Raphaelites in Britain, the beginnings of great changes can be discerned much earlier in France at the time of the revolution itself. The court art of Louis XV, of Boucher, Fragonard and Lancret represented all that the ordinary people most detested and which the intellectual politicians of the Revolution wished to replace with an art of social responsibility after the salacious frivolity of royal privilege. At least that is how they perceived it, and an alternative was available in what is called Neo-Classicism. Its leader was Jacques-Louis David, a friend of Robespierre and supporter of the Revolution, who created moral tracts espousing the cause of the revolution in pictorial form. It was the beginning, not only of a new way of painting and new subject-matter, but also the introduction of a new seriousness of purpose reflected in a determined historicism. The subjects were taken largely from Roman history, thus enlarging the discussion on what constituted the proper role of art.

It is not possible in this short introduction to pursue this matter through the various developments that occurred during the first half of the 19th century in France, but it is important to emphasize that the visual arts were in a process of change through the whole of the century, up to and following the Impressionists.

The situation in British art was different. From the beginning of the century a number of figures had emerged whose stature and influence in the arts was considerable. A realism in the treatment of nature, on the one hand,

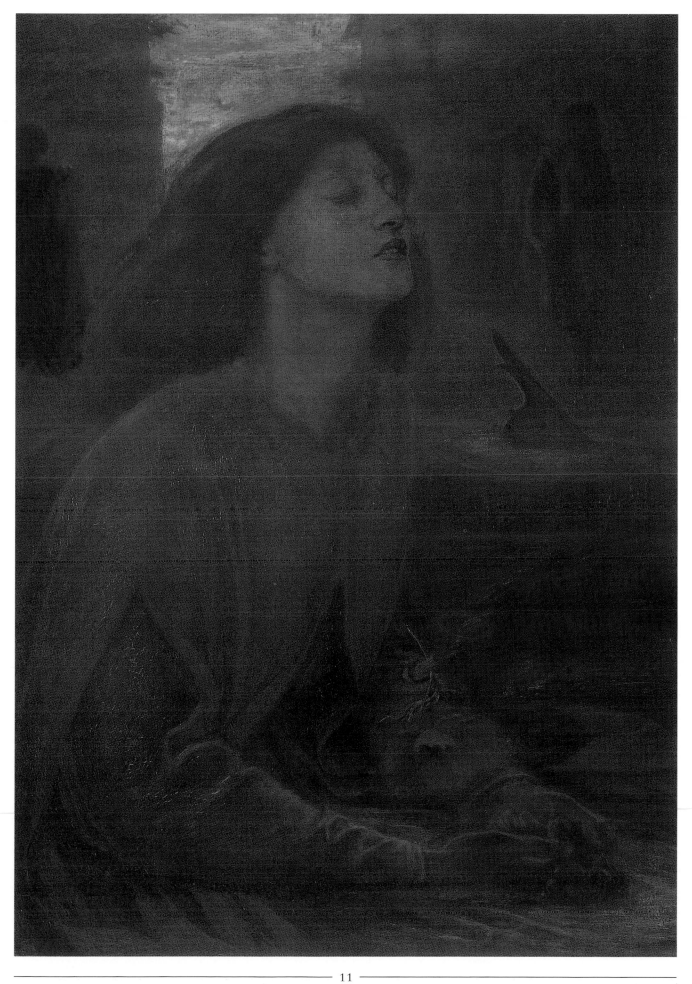

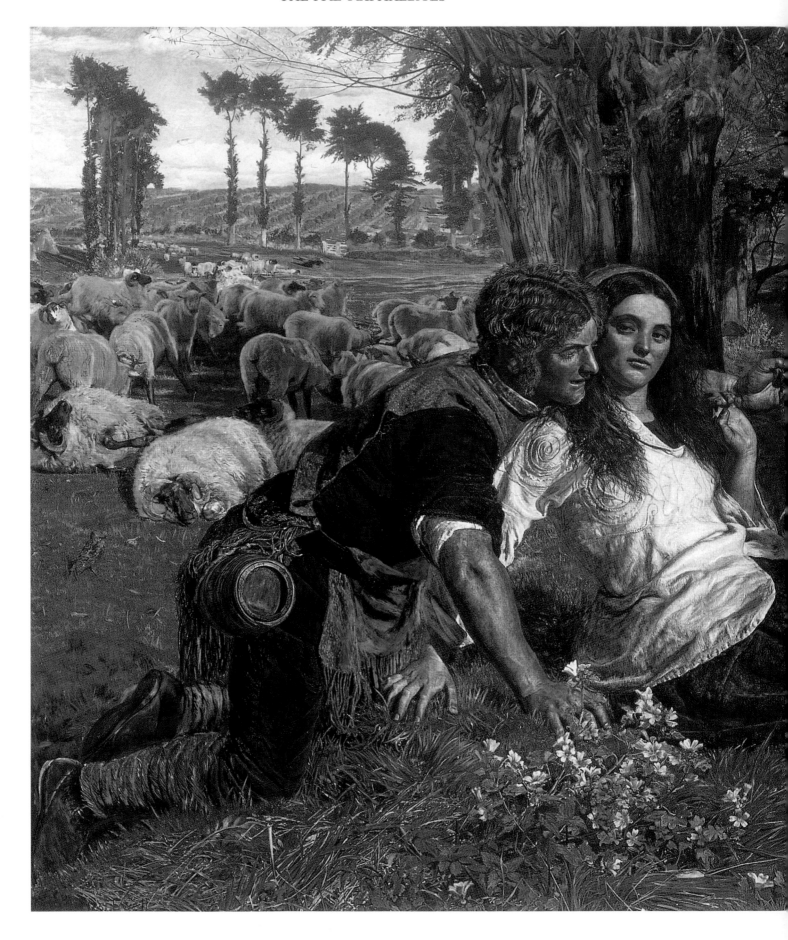

PLATE 2
The Hireling Shepherd (1851)
William Holman Hunt (1827–1910)

Oil on canvas, 30 x 42$^{1}/_{2}$ inches (76.2 x 108cm)

Sleepest or wakest thou, jolly shepherd?
Thy sheep be in the corn:
And for one blast of thy minikin mouth,
Thy sheep shall take no harm.
This quotation from Shakespeare (Edgar's song in King Lear*)
accompanied what Hunt intended as a depiction of real peasants in
an actual setting to counteract, as he saw it, the baleful influence of
the pretty romanticism usually present in pictures of rural life. To
that end he searched, with Millais, for a suitable location and
decided on a field near Ewell in Surrey which he painted daily, on
site, from the beginning of July 1851 to the end of October. The
landscape was his principal interest but before he returned to London
with a white area in which he would introduce the figures, he
painted the sheep. These were not good or willing sitters and had to
be captured and held by servants. The shepherd was a professional
model and the shepherdess a local Ewell girl. There is the inevitable
symbolism in the painting of the hireling shepherd neglecting his
responsibilities while showing his girlfriend a death's head moth he
has caught (which Hunt used as a representation of superstition).*

romantic with J. M.W. Turner, academic with John
Constable, and spiritual or mystical with William Blake had
appeared in British painting without a parallel in France. By
the time the Pre-Raphaelites were formed in 1848, there
was considerable uncertainty within the art establishment as
to the future direction of painting. Some positive direction
was needed, some standards established. The Pre-Raphaelite
Brotherhood with its mysterious cryptogram PRB appearing
on its paintings, provided a different if unspecified direction.
It seemed to be concerned with a new form of realism, part
spiritually motivated, part presenting a new sense of
actuality. One of the difficulties inherent in any study of the
Brotherhood derives, for instance, from the fact that what
the Pre-Raphaelites inaugurated was so quickly adopted or
assimilated into the generality of later Victorian painting
that it is not immediately evident to the observer which are
Pre-Raphaelite paintings, which are influenced by the
movement, and which have absorbed sufficient of the
technique and philosophy for different pictorial ends. The
disentanglement of this complex scene is not easy and every
writer on the subject will make different selections to
illustrate particular points from a plethora of work available.
The choice is therefore a personal one and with so much to

choose from is unavoidably limited. It has been necessary to concentrate on the central, most important figures of the Brotherhood itself as well as some of its followers.

Since its foundation in the 18th century under the presidency of Sir Joshua Reynolds, a determined intellectual classicist, the Royal Academy had assumed an authority over the standards of British art and become the recognized home of academic excellence. It was the necessary prerequisite of acceptance as a serious artist that study in the schools set up by the Academy had been undertaken which would give automatic entry into a profession with social pretensions and ambitions. It would not have seemed appropriate for artists, during this early period, to have joined in with groups or movements. Their ambition would have been individual acceptance within the official system: to become a member of the Royal Academy or, in France, the Académie and the annual Salon.

As a result, it is something of a surprise to encounter, in 1848, the formation of the Pre-Raphaelite Brotherhood, secretly devoted to a revolutionary artistic programme which became, in the event, the first of the significantly influential art movements of the century. The Brotherhood was comprised of three highly talented painters, one less talented, one described as a painter who left no paintings, a sculptor, and the brother of one of the three who became a writer, art critic and the movement's chief apologist. Strictly, these seven were the only actual members of the Brotherhood. Had Pre-Raphaelitism as an idea, intention, philosphical and technical artistic inspiration or approach depended entirely on this original group, it would almost certainly not have attained the public recognition, respect and regard that it currently holds. The 'Brothers' were joined by friends and followers and the result was a large and wide-ranging body of work created during the middle and later years of the 19th century in Britain that was different from the then dominant academic art.

The significance of 1848 as the Year of Revolutions is important to the story of Pre-Raphaelitism. Among the many events of the year of change in European history was the meeting on Kennington Common on 10 April of the Chartists. This organized group's attempt to initiate parliamentary reform, supposedly backed by more than 5 million signatures, caused deep concern to the extent that Queen Victoria left London in response to fears of riots, the Houses of Parliament were protected by guns and soldiers sent there by the Duke of Wellington and the police were mobilized. Although the meeting failed in its intention to march on Westminster it attracted, it has been estimated,

PLATE 3 below
Autumn Leaves (1856)
John Everett Millais (1829–1896)
Oil on canvas, 41 x 29 inches (104.1 x 74cm)

After Millais' marriage to Effie, they lived for a time in Perth where this painting and The Blind Girl *(plate 18) were finished. The two girls in dark dresses were Effie's sisters, Sophie and Alice, with two local girls, Matilda and Isabella, who were the models for* The Blind Girl. *Millais' intention was to make 'a picture full of beauty and without subject' in contradistinction to the story-telling and symbolism of most Pre-Raphaelite and Victorian work. The result is an autumn mood of anticipation and fruitfulness imbued with a sense of the passing seasons and with children as images of transient youth, suggesting that all is change. It is a part wistful, part joyous, part nostalgic work of great attraction.*

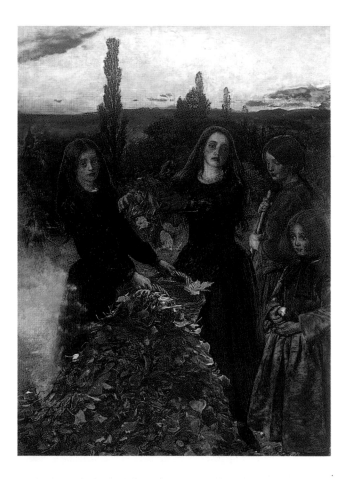

between 25 and 100,000 people, among them two young students from the Royal Academy Schools, William Holman Hunt and John Everett Millais, who were inspired to thoughts of artistic revolution as a result. It was the unlikely initiatory origin of Pre-Raphaelitism. The third important member of the Brotherhood was Dante Gabriel Rossetti who had seen a painting by Hunt, inspired by a poem of Keats. Rossetti admired the painting, was devoted

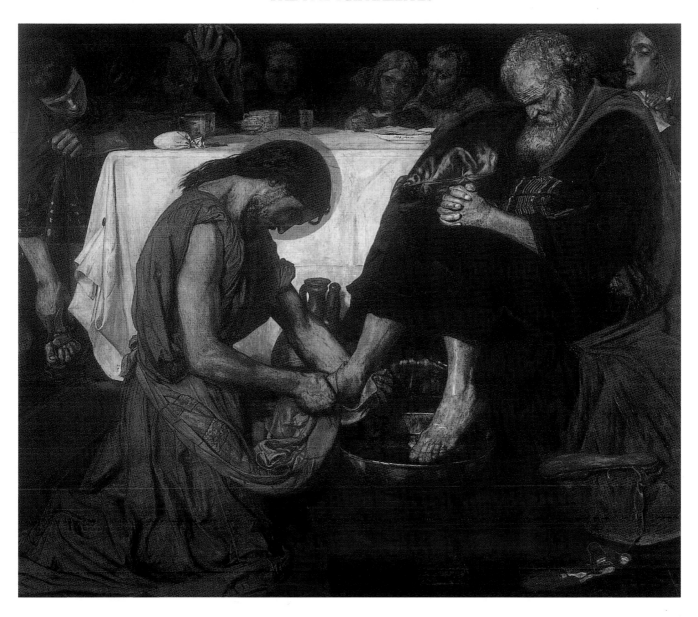

PLATE 4

Jesus Washing Peter's Feet (Christ Washing Peter's Feet) 1852–1856

Ford Madox Brown (1821–1893)

Oil on canvas, 46 x 52¹/2 inches (116.8 x 133.3cm)

The Pre-Raphaelites' practice of including quotations with their paintings, either in the form of an addition to the frame or in the exhibition catalogue is common and here, not unexpectedly, Brown included a quotation from the Bible (St. John 13,4–5, 15). 'He riseth from supper and laid aside his garments; and took a towel and girded himself. After that he poureth water into a basin, and began to wash the disciples' feet, and to wipe them with the towel wherewith he was girded. For I have given you an example, that ye should do as I have done to you.' The scene may be examined in the light of this text and Brown has added a number of details

emphasizing through the low viewpoint, that of Christ, the viewer's participation in the action from Jesus' level while Peter, who has declined Jesus' offer, saying 'Thou shall never wash my feet', sits in troubled resignation. On the left, Judas leans forward to undo his sandals for the service while keeping at his elbow the bag of silver which is his identifying symbol. Brown used models and friends for the figures, notably F. G. Stephens for Christ, while Peter was probably a model. Both William Rossetti (next to Judas) and Dante Gabriel (bearded near the head of Peter) appear and the figure in the top right corner has been identified as Christina Rossetti – although she denied that she sat for Brown. The foot bowl hangs over the edge of the platform, recalling Caravaggio's use of this observer-involving device in his Supper at Emmaus *(National Gallery, London).*

PLATE 5
Our English Coasts ('Strayed Sheep') 1852
William Holman Hunt (1827–1910)
Oil on canvas, 17 x 23 inches (43 x 58.4cm)

It might seem – indeed has seemed to the general observer that this is a closely studied painting of sheep in a verdant coastal setting and that, however effectively constructed, it is intended only as a study and may be admired as such. But Hunt was dedicated to symbolism and more lay behind the physical reality. Sheep are often used as symbols of humankind and its behaviour and several interpretations of Hunt's intention have been offered. Once described as 'Strayed Sheep', it offers the notion of human indecision, of danger on the brink of destruction. It also carries the implication of Christians as straying sheep and the fact that the sheep are on the edge of the cliff, the end of England, implies what was the real perception at that time – of danger to Britain from invasion by Napoleon III. More might be introduced but Ruskin, who was already becoming an important arbiter and opinion-former, emphasized the qualities of the actual painting in observing that 'for the first time in the history of art' it revealed 'the absolutely faithful balances of colour and shade through which actual sunshine might be transposed' into a painting.

to Keats' poetry, became anxious to learn from Hunt and sought him out at the Academy Schools. At this time Millais was 19, Rossetti was 20 and Hunt 21 and the Brotherhood was the product of their youthful enthusiasm and revolutionary distaste for (as they saw it) the arid superficial academic style. They were joined by Rossetti's brother William Michael, Thomas Woolner, James Collinson and Frederic George Stephens, who together formed the original seven members of the Brotherhood.

Before considering the movement itself, it is perhaps important to note some significant and relevant aspects of Victorian society and history. In the 18th century, the great industrial revolution was taking place in Britain and by the early 19th century this was reflected in the growth of great national wealth and the worldwide might of the last great Imperial power. The arrogance and self-satisfaction that resulted created a divided society with a rigid class structure. The importance of this division was that, while it increased the isolation of the aristocracy and identified very clearly the workers and their poverty, it also saw the rise of a power-hungry and ambitious middle class in whom a great deal of the wealth and energetic talent was concentrated. It was not only the poor that yearned for reform. There was a wide range of middle-class yearning for change.

It is also significant to recall that 1848 also saw the publication of the First Communist Manifesto of Marx and

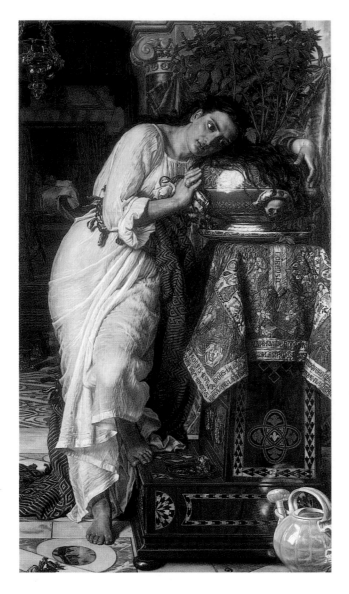

PLATE 6
Isabella and the Pot of Basil (1867)
William Holman Hunt (1827–1910)
Oil on canvas, 73 x 44¹/2 inches (185 x 113cm)

The story illustrated here is outlined in Millais' painting of a different episode in the story of Isabella as recounted in Keat's poem (plate 16). Hunt is depicting Isabella mourning over the pot of basil which contains the head of her lover Lorenzo. The painting was begun in Florence as a portrait of Fanny Waugh, Hunt's then pregnant first wife, who died there in 1866 after giving birth to a son. Hunt returned to London with the child and finished the painting in London, renaming it when finished. It was a memorial to his deep love, reflected in the voluptuous figure, and recalls Keats' story of young lovers separated by early death.

opportunities for increasing wealth, were examined in such works as John Stuart Mill's *Principles of Political Economy* (1848). The writings of Charles Dickens in such books as *Oliver Twist, David Copperfield* (published in 1849) and *Little Dorrit* reflected the deprived life of the lower levels of society while the extraordinary Brontë family of writers produced some of the greatest novels of the Victorian age; Anne, *The Tenant of Wildfell Hall* (1848), Charlotte, *Jane Eyre* (1847) and Emily, *Wuthering Heights* (1847). Anthony Trollope, writing of life on a more elevated level of society began his series of Barsetshire novels in 1855 with *The Warden*. In short, the Pre-Raphaelites were active during the period of the highly creative and energetic Victorian age and appreciably contributed to the present perception of its cultural importance.

It was also the beginning of what has been called the Age of Steam – the advent of the rail system and the steam-powered new industrial factories which first appeared when the young painters of the Brotherhood were born, and which provided yet another impetus for change by the time they were adults. Modern society was in a period of gestation and a few visionary spirits desired to participate in the changes they foresaw.

THE SPIRIT OF PRE-RAPHAELITISM
As recounted by Hunt, the name of the Brotherhood was decided upon one evening while the group were looking through a volume of Lasinio's engravings of the frescoes in the Campo Santo at Pisa which had been published in 1828. It should be appreciated that the availability of illustrations of art at this time was very limited and then only in engraved

Engels and that Darwin's *Origin of Species* appeared only ten years later. The effect of these two publications on later Victorian thought and belief was profound. In the context of the art of the day, the shocking effect of Darwin's work upon the certainties of Christian faith stimulated new intellectual curiosity into the nature of life and art. At this same time, the physical appearance of the cities and landscape was being changed by industry as 'the dark Satanic mills' of William Blake's imagination began to cast a pall over the nation. The divided communities of the Christian faith were each engaged in building new places of worship for the expanding population of the cities and in the process were creating the Victorian Gothic style in Britain. This initiated what has come to be called the Battle of the Styles – medieval in opposition to classical. While Britain was expanding, building its Empire and creating enormous wealth in the process, the intellectual life of the country was at its most confidently energetic and wide-ranging in its interests. The sociological and cultural effects, as well as the

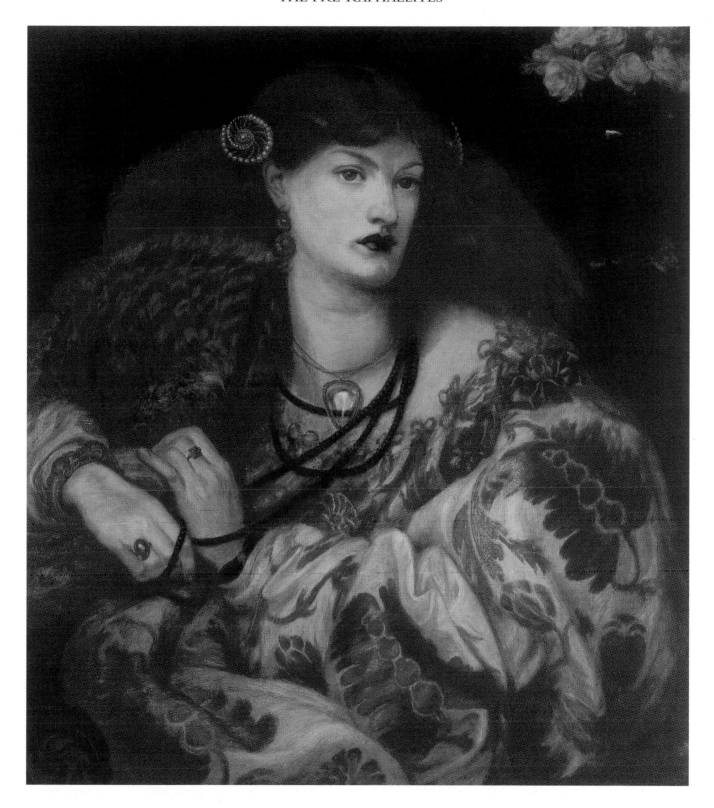

PLATE 7
Monna Vanna (1866)
Dante Gabriel Rossetti (1828–1882)
Oil on canvas, 35 x 34 inches (89 x 86.4cm)

Gone are the sensitivities of such paintings as Beata Beatrix
*(plate 1) in this bold and decorative study of a model, Alexa
Wilding, employed by Rossetti at this time. She is displayed in an*
*exotic and sumptuous costume with bold unreflective eyes and a
self-indulgent mouth. There is no specific association in the title
chosen by Rossetti when the painting was finished, save that it
appeared to him to have Italian, particularly Venetian,
characteristics (he originally titled it 'Venus Veneta'). Rossetti
described it as probably the most effective room decoration that he
had ever painted – a telling observation on the portrait subjects he
was painting in the 1860s.*

copies. It should also be understood that Raphael was regarded in the academic, artistic world as having reached the apogee where Renaissance art was concerned. This viewpoint was particularly strong in England where the great Raphael cartoons could be seen at Hampton Court, then the greatest Italian Renaissance art works in existence outside of Italy. It is not precisely recorded how and why they chose Raphael but it certainly suggests some sort of quality challenge. Earlier in the century the German group, the Nazarenes, formed as a brotherhood in Vienna and later moving to Rome, had looked back to the late Middle Ages for their inspiration, with its deep religious faith and simple social structure. Stylistically, however, they were influenced by Perugino and Raphael and this also affected the Pre-Raphaelites to the extent that they appear to have been influenced in their choice of name.

This is not to say, however, that the Brotherhood was universally admired when it first appeared. Much of its acceptance was due to one of the most powerful cultural artistic voices of the century, John Ruskin, who was persuaded by the writer Coventry Patmore to come to the assistance of the Brotherhood in 1851, first in two letters to *The Times* and later in a pamphlet. Ruskin's first enthusiasm had been for Turner, in whose praise he had begun a work with the original intention of establishing Turner's supremacy but which eventually grew to a five-volume survey of the history of European art. He had no great enthusiasm for the Pre-Raphaelites even though, for a time, he came to believe that one of them was a worthy successor to Turner. It is difficult to overstate the importance of Ruskin's influence during the middle years of the Victorian age. That he is again now being reappraised is a measure of his real significance. His importance to the Pre-Raphaelite revolution lies, not so much in his analysis of historical European art, but in the position that he occupied through his interest in the art of his own time, its 'living' art, for which he provided both commentary and standards. Whether we accept all that he claimed, he nevertheless created personal art criticism as a programme for the middle classes to a degree never seen before or since. He was not an easy man and William Gaunt in his revealing *The Pre-Raphaelite Tragedy*, described him as '... a puzzling individual. He puzzled his contemporaries as he has puzzled many since.' And later, on the influence of his progenitors, 'the priggish voice of an only, sternly pampered son ... the gleeful puckish voice of a crazy imp.' Nevertheless, he was a great figure and his voice was imperious and effective.

PLATE 8

John Ruskin at Glenfinlas (1853–1854) detail
John Everett Millais (1829–1896)
Oil on canvas, 31 x 26³/4 inches (78.9 x 67.9cm)

The intriguing background to this painting is discussed on page 39 and detailed in full in Mary Lutyens' book, Millais and the Ruskins. *The qualities of the painting itself have not been evaluated and these are considerable. The extraordinary care and attention to detail of the natural surroundings, which would have been an important requirement by Ruskin, is evident, and a number of preparatory drawings and at least one careful oil study were made. Millais' abilities as a draughtsman are inherent throughout the work and the figure confirms Millais' own intention: 'I am going to paint him looking over the edge of a steep waterfall – he looks so sweet and benign standing calmly looking into the turbulent sluice beneath.' The direction from which the head is viewed is the one from which he is usually portrayed and avoids revealing the scar Ruskin had received from a dog bite as a small child. This is one of the great portraits of a great Victorian figure who was an exact contemporary of Queen Victoria herself.*

THE BROTHERHOOD

The three most important members of the Brotherhood were John Everett Millais, Dante Gabriel Rossetti and William Holman Hunt. The other four members were the painter James Collinson, who resigned in 1850, Thomas Woolner, a sculptor who emigrated to Australia, F. G. Stephens, who began as a painter but became a supporter and critical writer, and William Michael Rossetti, the brother of Dante Gabriel who became a critic and promoter of the group. If therefore we were to concentrate strictly on the Brotherhood we would have only three major artists to consider, Millais, Rossetti and Hunt, and one minor, James Collinson. But this would be to restrict the study unrealistically, since the artistic intentions of the original Brotherhood were, as we have noted, adopted enthusiastically by a large number of followers, some of whom are widely believed to have been part of the group from the beginning and are always included in any survey: most notably Ford Madox Brown, Arthur Hughes and Edward Coley Burne-Jones.

To establish this philosophy and its artistic expression it is necessary to examine the background of the participants. In the revolutionary year of 1848, the three were very young and rebellious, earnest and devoted but cultured, educated, high-spirited and iconoclastic. Their lives were unconventional: irregular relationships with women, involvement with drugs, Christian fanaticism, suicides –

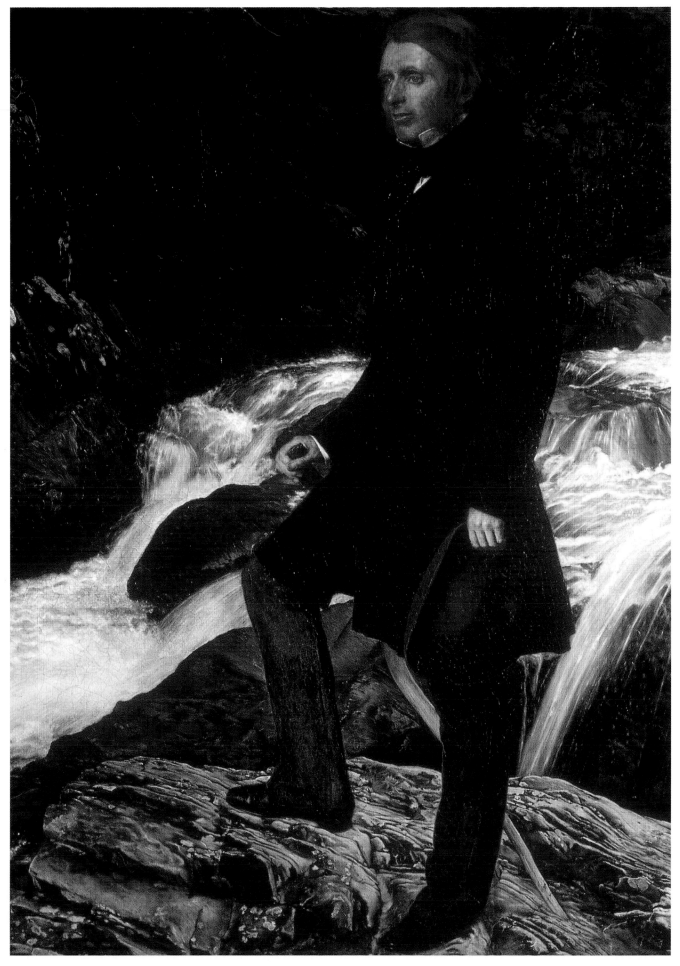

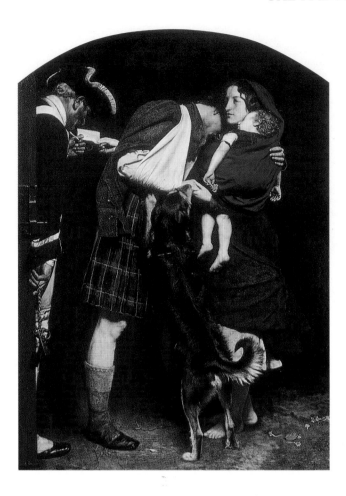

PLATE 9 left
The Order of Release 1746 (1852–1853)
John Everett Millais (1829–1896)
Oil on canvas, 40¹/₂ x 29 inches (103 x 74cm)

A scene from the Jacobite Rebellion and presumably occurring after the fearful massacre of Culloden and the defeat of Bonnie Prince Charlie. His wife has secured the rebel's release and hands the paper to the jailer. The model for the head of the wife is Effie Ruskin, soon to become Millais' wife who, as a Scot herself, was pleased with the painting, 'quite Jacobite and after my own heart'. The painting attracted a great deal of attention in the 1853 Royal Academy show and is an example of Millais' technical brilliance and sense of the dramatic; there is a curious ambivalance on the face of the wife – defiance and triumph or possibly the loss of her own virtue which has communicated itself to her shamed husband – nothing explicit, but open to conjecture.

PLATE 10 opposite
Mariana (1851)
John Everett Millais
Oil on panel, 23¹/₂ x 19¹/₂ inches (59.7 x 49.5cm)

Untitled in the Royal Academy Exhibition of 1851, the picture was accompanied by a quotation from Tennyson's poem 'Mariana':
She only said, 'My life is dreary,
He cometh not,' she said;
She said, 'I am aweary, aweary,
I would that I were dead!'

As Mariana stands stretching her tired back, the fallen leaves of autumn suggest the end of the growing cycle of light and the long dispiriting winter to come. The contrast, in bright bold colour, of the Annunciation scene in the stained-glass window, contrasting the Virgin's fulfilment with Mariana's langourous unhappiness, is typical of the underlying message frequently, if not almost invariably, symbolically expressed in Pre-Raphaelite paintings.

not the everyday world of prim Victorianism. They could be considered to fit the popular perception of the wild artist. While they remind us of the young Impressionists of the next generation in France, they were in spirit perhaps much closer to the young painters of the first years of this century, Matisse, Picasso and their contemporaries. Independent and irreverent, they required a new art and formed together as a secret society to establish it. The Brotherhood was sworn to secrecy (which caused trouble later) and its members only identified themselves by appending the letters PRB to their signatures on their paintings. As an organization it was short-lived: formed in 1848, it barely survived the 1851 Academy and was certainly at an end by 1853. Rossetti ascribed the election of Millais as Associate Royal Academician as precipitating the end of the Brotherhood.

THE ARTISTS
The three central figures, William Holman Hunt, John Everett Millais and Dante Gabriel Rossetti were born within three years of one another and were very different in character, each bringing his individual qualities to the creation of Pre-Raphaelitism. Since the Brotherhood lasted as a coherent entity for only five years at most and in 1848,

when as we have seen it was officially formed, they were respectively 21, 19 and 20, it was clearly a youthful development, characterizing all the qualities and deficiencies of youth. It was enthusiastic, energetic, iconoclastic, irresponsible, aggressive, self-assured and hardworking. When one looks at the paintings that the group produced, and being mindful of these qualities, it is with some element of disbelief that we regard these careful, infinitely detailed and intellectually serious works. Are they truly the work of young revolutionaries? One pictorial element that identifies both members and followers is a careful and rigorous technique and a devotion to accurate representation of

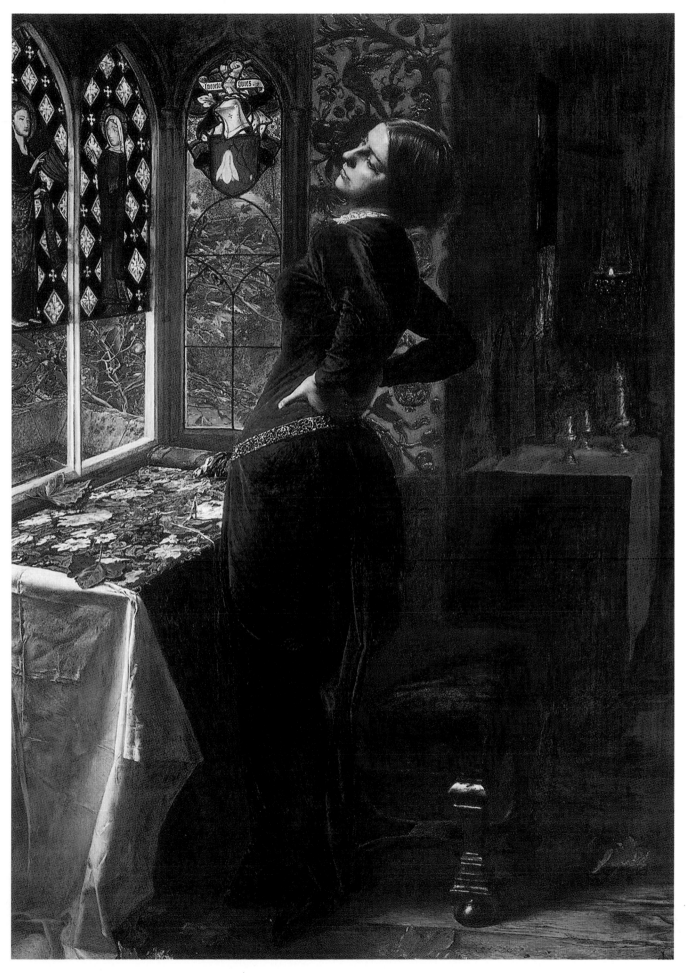

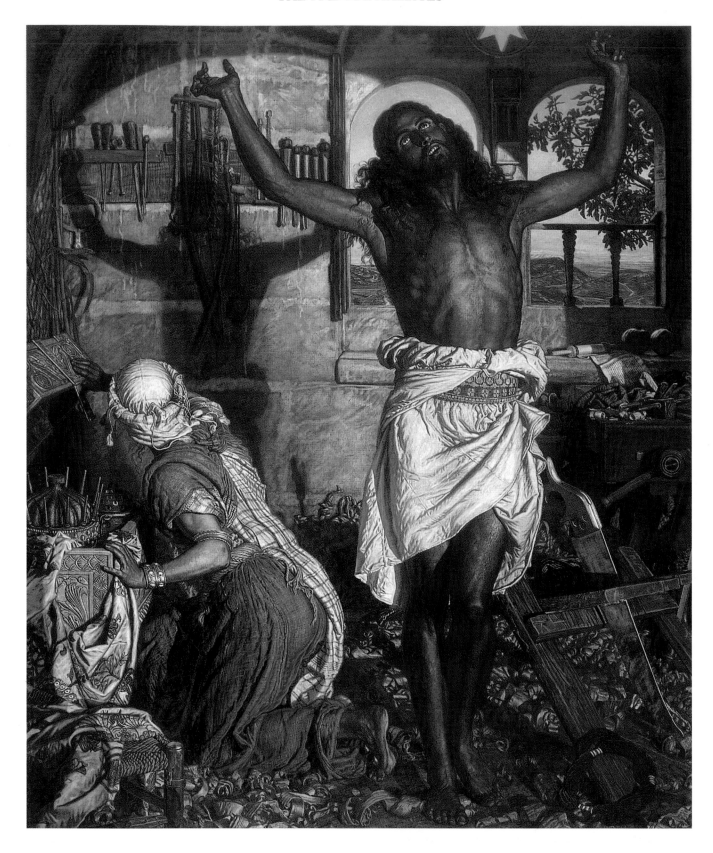

nature: although scrupulous care and hard devoted work may not be common characteristics of the revolutionary, it was true of these young painters. It was their concern with truth to nature that attracted Ruskin to their defence as it had earlier been his writings on the same subject that had partly motivated them.

The second and more obvious characteristic of the work of Hunt, Millais and Rossetti, which partly explains the name they chose, was their interest in the period of the late medieval and early Renaissance where they identified a purer, less sophisticated approach to the subject than could be found in the classically dominated structure of High

PLATE 11

The Shadow of Death (1870–1873)
William Holman Hunt

Oil on canvas, 83¹/₂ x 66 inches (212 x 167.6cm)

Painted after his arrival on his second visit to the Holy Land in 1869, the work was begun in a carpenter's shop in Bethlehem and Hunt, as usual, paid great attention to the details of the interior, notably making a careful study of the tools – disposed on the wall to cast the shadow of the cross, thus presaging the Crucifixion. The painting was continued in Jerusalem and was not finished until 1873. During the whole of this time, Hunt was depressed and mourning the death of Fanny Waugh, his wife, so that the painting itself became a protracted contest 'with the powers of chaotic

darkness'. Hunt explicitly emphasized the actuality of the scene as far as he possibly could as he wished to present Jesus as a young man working in a carpenter's shop, much as Millais had done earlier, but with a greater sense of realism and religious awe than Millais. At the same time, he was also emphasizing the 'modern' view of Christian life. He described his intention in a letter to an unidentified correspondent, asserting ' … with my particular picture and old religious priest teaching I see nothing at all in common … my picture is strictly historic with not a single fact of any kind in it of a supernatural nature, and in this I contend it is different [from] all previous work in religious art.' The painting was bought by Agnew's, the London dealer for £10,500 – a considerable sum in those days.

Renaissance work, of which Raphael was the archetypical master and, incidentally but significantly, the great model of mid 19th-century academicism. It was the art before Raphael that engaged their interest: in a way Raphael had nothing to do with it.

It is also important to note that the period they chose for their historical subject-matter was pre-Reformation Christianity. In this they were influenced by the Nazarenes, who flourished in the early decades of the century and chose late-medieval subject-matter for their paintings. The Pre-Raphaelites were, in principle, devout Christians although their behaviour, as it has subsequently been established, does not even appear to meet Christianity's most liberal criteria.

When they turned their interest to social realist painting, the Pre-Raphaelites took their technique and intellectual attitudes with them so that there is a coherence of style within the wide range of technical accomplishment and distinction of mind of both the Brotherhood and its followers. It is their differences as well as those things that link them that must be considered in the life and work of each individual.

WILLIAM HOLMAN HUNT (1827–1910)

Although Millais and Rossetti have, for differing reasons, become the best known of the Pre-Raphaelites, Holman Hunt was always the central figure of the movement, its historian and most effective apologist. The oldest, he had already achieved some recognition when the Brotherhood was formed and was its natural leader. Additionally, he was the only one who remained loyal to the Pre-Raphaelite principles throughout his long life.

He was born in Cheapside, London, the son of a father who was in business, and who was opposed to William's wishes to become a painter. Consequently, at the age of 13, he was placed by his father in an estate agent's office but saved enough of his wages to take lessons in portraiture by the time he was 16. He later gave up work and, studying part of the time in the British Museum and the rest painting portraits, managed to support himself. He was admitted to the Royal Academy Schools as a probationer in 1944, after two unsuccessful attempts. In the following year he exhibited his first picture *Hark* – a child holding a watch to her ear. More significantly at this time he met the infant prodigy of the Academy, John Everett Millais, admitted at the age of ten and two years younger than Hunt, who described Millais as 'already, at the age of seventeen, the precociously efficient medal student of the Royal Academy'. They became friends and discussed the current state of painting and their own ambitions, Millais professing a need for the closest study of nature which accorded well with Hunt's own views. In 1848, as recorded above, they attended the great Chartist meeting on Kennington Common which excited their young ambitions: during the same year Hunt introduced Millais to Rossetti. The core of the Brotherhood was thus formed and Hunt was regarded as its leader, sometimes referred to as its president, when the other members were introduced. Hunt also introduced the writings of Ruskin to the group at this time – Ruskin was about ten years older than the members and had already achieved a growing reputation. The first volume of *Modern Painters*, his defence of Turner, had appeared in 1843 when he was 24.

Hunt's philosophy was based in the value of labour and

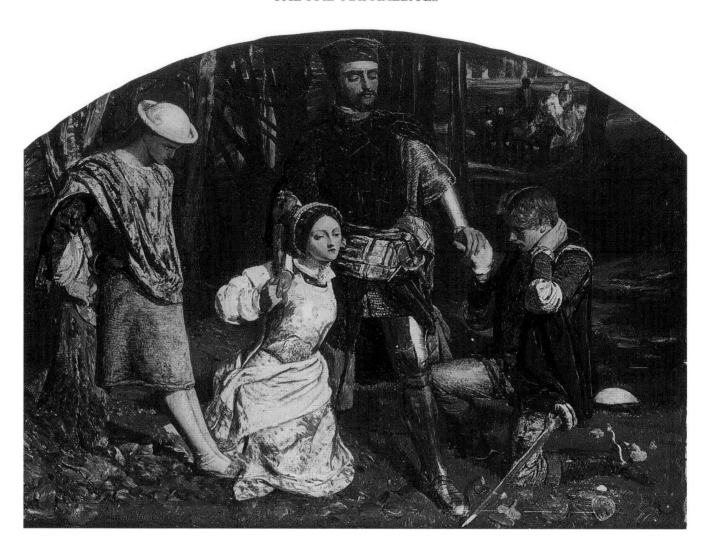

PLATE 12 above
Valentine Rescuing Silvia from Proteus
(1851)
William Holman Hunt
Oil on canvas, 38³/4 x 52¹/2 inches (98.4 x 133.4cm)

The scene depicts the moment near the end of Shakespeare's Two Gentlemen of Verona when Valentine arrives to discover his trusted friend Proteus attempting to seduce Silvia whom Valentine loves. But the play ends happily; Valentine forgives Proteus (indicated by their clasped hands) and Proteus is reconciled with his real declared lover, Julia (seen on the left disguised as a youth). In the background the Duke of Milan, Silvia's father, can be seen, and he comes forward at the end to add his blessing and resolve the loose ends. It is a comedy of surface passions and Hunt captures its spirit most effectively.

The wooded scene was painted in the grounds of Knole House, near Sevenoaks, Kent, and Hunt, as usual, induced friends to sit as models including, reluctantly, Elizabeth Siddal. The painting was exhibited in the Royal Academy exhibition of 1851 and like all the other PRB paintings was violently attacked by the critics. Even Ruskin, whose letters to The Times in May 1851 were the first

(and most powerful available) support for the Brotherhood, criticized the commonness of Silvia's features as the only weakness in the painting, an opinion hardly calculated to please Lizzie Siddal.

PLATE 13 opposite
The Light of the World (1854)
William Holman Hunt
Oil on canvas, 48 x 24 inches (122 x 61cm)

Hunt had a deeply religious nature which directly underlay much of the inspiration for his work and which is plainly evident in this famous painting, an icon of the human figure of Christ which has been reproduced worldwide. It illustrates a passage from Revelations 3, 20 which is inscribed on the frame: 'Behold, I stand at the door, and knock: if any man hear my voice, and opens the door, I will come into him, and will sup with him, and he with me.' Confirmation of Hunt's own belief and his view of the work comes in a letter written to a friend, William Bell Scott, stating that he 'painted the picture with what I thought, unworthy though I was, to be divine command, and not simply a good subject'. Hunt originally intended to set it by day but the Bible reading convinced him that a greater effect would be achieved by setting it at night, lit by a lantern which symbolizes Christ as the Light of the World.

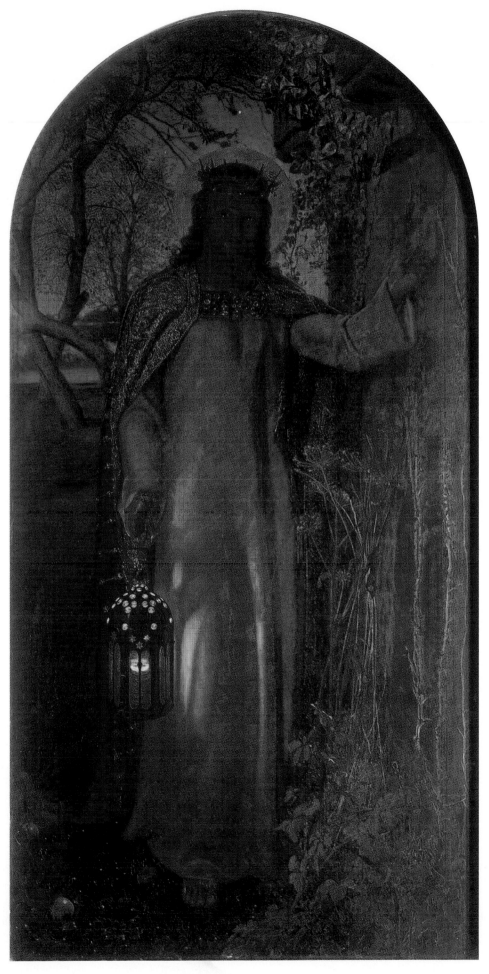

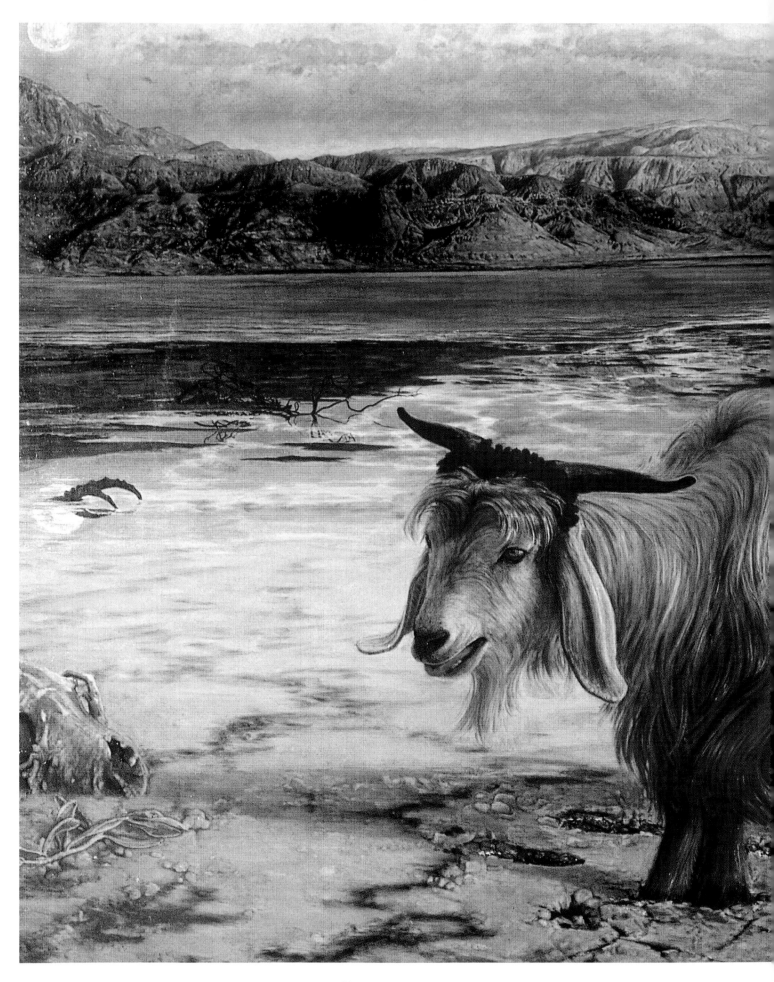

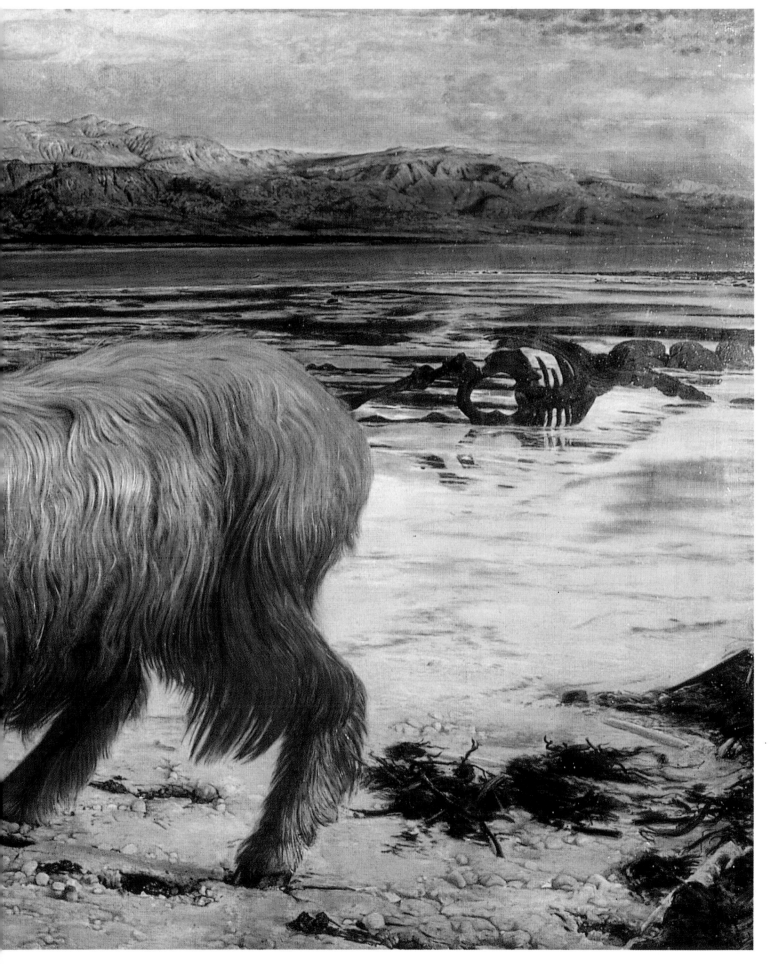

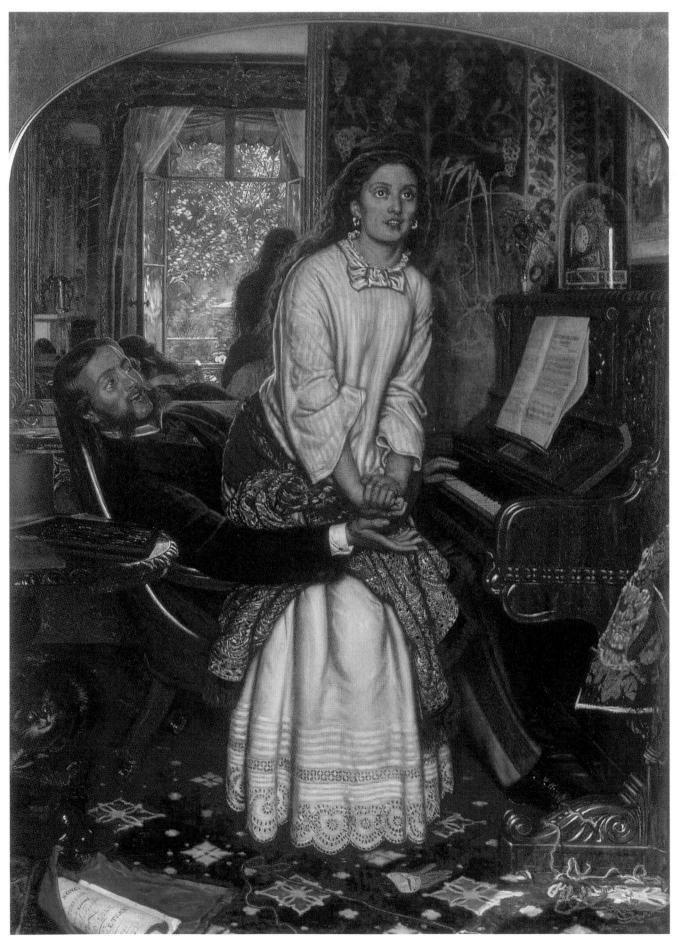

PLATE 14 (pages 28–29)
The Scapegoat (1854)
William Holman Hunt
Oil on canvas, 33³/4 x 54¹/2 inches (85.7 x 138cm)

This strange and haunting painting was completed on Hunt's first visit to the Middle East in 1854. It has been the subject of much comment since it was first exhibited in the Royal Academy exhibition of 1855 when it gave rise to considerable puzzlement. Ford Madox Brown's view of the work, noted in his diary, was that 'Hunt's Scapegoat requires to be seen to be believed in. Only then can it be understood how ... out of an old goat, and some saline encrustations, can be made one of the most tragic and impressive works in the annals of art'.

The painting is inspired by the Talmudic tradition of the sacrificial white goat taken to an isolated location in the wilderness on the Day of Atonement. It was believed that the red braid bound around the goat's horns would turn white if it was an acceptable propitiation. An inscription on the frame explains the passage 'And the goat shall bear upon him all their Iniquities unto a Land not inhabited.'

the technique he adopted, which became essentially the Pre-Raphaelite method, involved hard and intense work over many months to complete a picture, even a number of years in some instances. Later he confessed to being 'weary of work – I can't get anything finished'. His character was serious, dedicated and highly moral and this is reflected in his painting. He was religious though cheerfully irreverent in his early days and what is called a 'good companion'. His appearance, with his mass of red hair and a bushy beard was reminiscent of an Old Testament prophet. The underlying moralizing spirit, derived directly from Ruskin, is evident in all his work, from religious to genre subject-matter and the last of his paintings completed during the life of the Brotherhood in 1853, provide an example of each in *The Light of the World* and *The Awakening Conscience*. In the first, Christ is shown carrying a lantern and knocking on a door in what has become one of the most famous images of the Saviour reproduced worldwide (plate 13). The second presents a moral message, i.e. the penalties of prostitution (plate 15).

In 1854 Hunt visited the Holy Land with the intention of introducing a greater sense of accuracy into his work. His aim was to paint, on the spot, subjects inspired by Christianity, the first being his famous image of *The Scapegoat* (plate 14), an enigmatic and eccentric work of extraordinary power. Other paintings emerged from this first trip, notably *The Finding of the Young Saviour in the*

PLATE 15 opposite
The Awakening Conscience (1854)
William Holman Hunt
Oil on canvas, 30 x 23 inches (76.2 x 58.9cm)

In this painting, Hunt makes an early attempt to engage with a central social problem, that of prostitution, which was one of the subjects that writers from Dickens to Zola dealt with in their novels. The picture is a propogandist warning and the symbols are the everyday objects which surround the lovers, innocent in themselves but pregnant with meaning in their context. Ruskin, in a letter to The Times wrote: '... nothing is more notable than the way in which even the most trivial objects force themselves upon the attention of a mind which has been fevered by violent and stressful excitement.' The painting caused much discussion when it was first exhibited in the 1854 Royal Academy. It was attacked by the Athenaeum which described it as being 'drawn from a very dark and repulsive side of domestic life'. Almost every object in the painting carries a message, none more significant perhaps than the ray of sunlight that advances across the room from the bottom right corner, carrying the hope or promise of possible redemption.

Temple. This painting was highly praised, sold for a large amount and Hunt was thereafter financially secure, selling his work for ever-increasing sums.

In 1865, while Hunt was in Florence painting, he married his first wife, Frances Waugh (Fanny), who died a year later leaving a son. Ten years later he married Fanny's sister Edith although he had to take her abroad to do so, it being illegal in Britain at that time to marry siblings. This weighed on his mind and remained with him as a source of guilt for the rest of his life and with his widow as an obsession. Nevertheless, he worked with unremitting zeal for the remainder of his life, surviving all the other Pre-Raphaelites although he was the eldest.

SIR JOHN EVERETT MILLAIS P.R.A. (1829–1896)

It is difficult to think of any painter in the history of art who showed such precocious talent as Millais. If his later achievements had been equal to his astonishing beginnings one might now be comparing him with Mozart or Masaccio; but his technique and social ambition, together with an essentially banal mind, resulted in his producing a large number of portraits and many excessively sentimental paintings. Nevertheless, during the early years and up to about 1860 he produced some of the most brilliantly executed paintings of the Pre-Raphaelite group.

He was born in Southampton but came from an old

PLATE 16 right

Lorenzo and Isabella (Isabella) 1849

John Everett Millais (1829–1896)

Oil on canvas, 40 x 57 inches (101.6 x 144.8cm)

Keats was a favourite poet with the Pre-Raphaelites and both Millais and Hunt chose his Isabella, *or* The Pot of Basil *as the subject for a painting. Millais was the first to paint it after the formation of the Brotherhood and the picture was signed with the initials PRB after his signature and also carved into the seat in the bottom right of the painting. It was exhibited next to Holman Hunt's* Rienzi *in the Royal Academy of 1849 and the catalogue carried an extract from Keats' poem. Taken from Boccaccio, the poem relates the story of the love of Isabella for Lorenzo, an employee of her brothers who, furious at her failure to make a better (more profitable) marriage, murder him and bury the body in a forest. Isabella exhumes the body, cuts off the head and stores it in a pot covered with basil. The brothers find it and flee – Isabella dies of a broken heart. In the painting Isabella and Lorenzo are on the right sharing a blood orange. The brothers are on the left. The characters in the painting are portraits of Millais' friends or relatives.*

PLATE 17 (pages 34–35)

Christ in the House of His Parents (The Carpenter's Shop) 1850

John Everett Millais

Oil on canvas, 33 x 54 inches (83.8 x 137.2cm)

This painting was first exhibited in the Royal Academy Exhibition of 1850, without a title, but with a quotation from Zachariah: 'And one shall say unto him, What are these Wounds in thy hands? Then he shall answer, Those with which I was wounded in the house of my friends.'

The painting was viciously attacked as deeply disturbing to the faithful's romantically remote and idealized conception of the life of Christ, as usually presented. Its realism offended viewers and the numerous critics were led by Charles Dickens in his periodical Household Words *in which he described the work as 'mean repulsive and revolting' and the young Christ figure as 'a hideous, wry-necked, blubbering, red-haired boy in a nightgown, who appears to have received a poke playing in an adjacent gutter, and to be holding it up for the contemplation of a kneeling woman, so horrible in her ugliness that ...' – and the review continues in that vein.*

established Jersey family of which he was the youngest son. He entered the Royal Academy Schools in 1841 at the age of 11, having been awarded a silver medal by the Royal Society of Arts at the age of nine when already a pupil in the Academy of the painter Henry Sass, a preparatory study

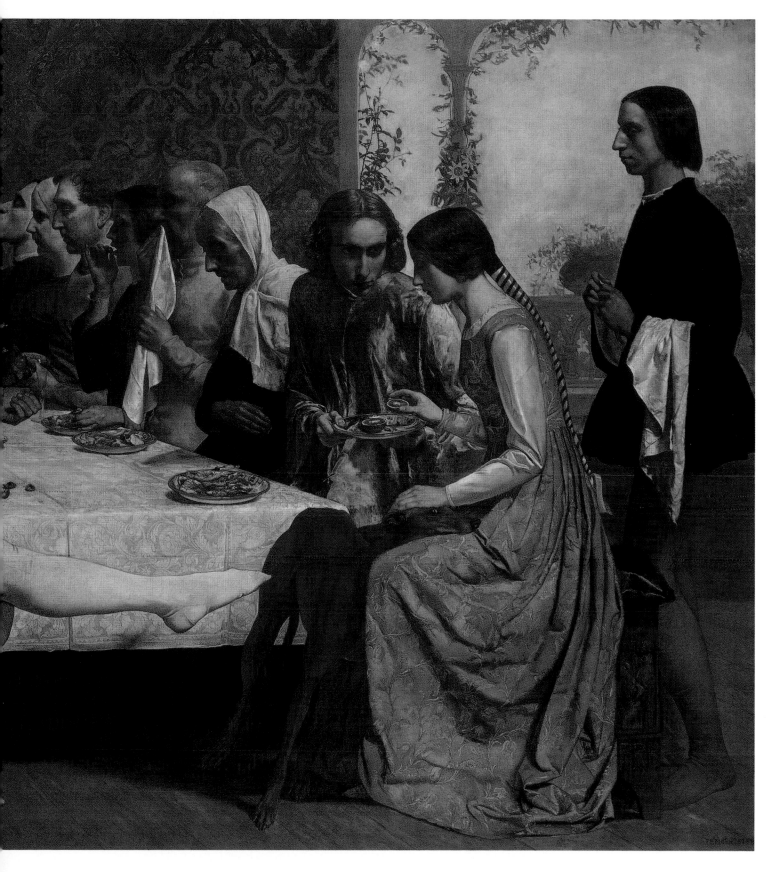

centre for the Academy Schools. The youngest student on record at the Academy Schools, he was known as 'The Child', described by Gaunt as 'a quaint angelic little creature'. At 17 he exhibited *Pizarro Seizing the Inca of Peru*, a work equal to the best historical paintings of the day and in the following year was awarded a gold medal for another historical work. There is no doubt that his was a unique precocity and he displayed a sensational ability to master any technique available. It is perhaps this very ability that in the last analysis was his greatest handicap. Since he could

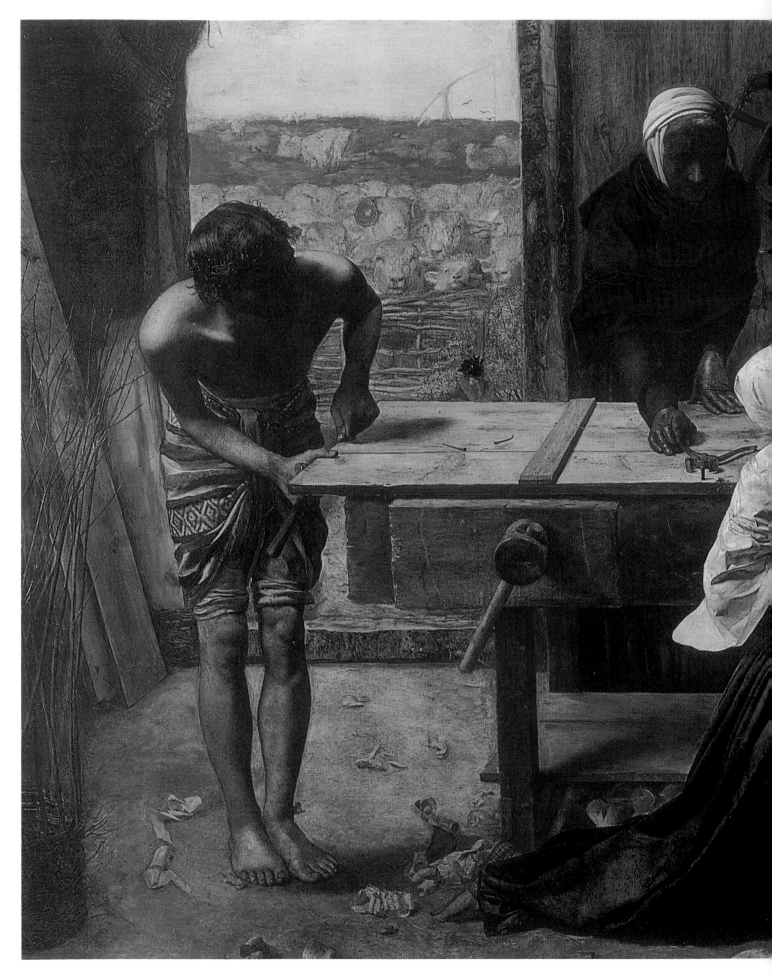

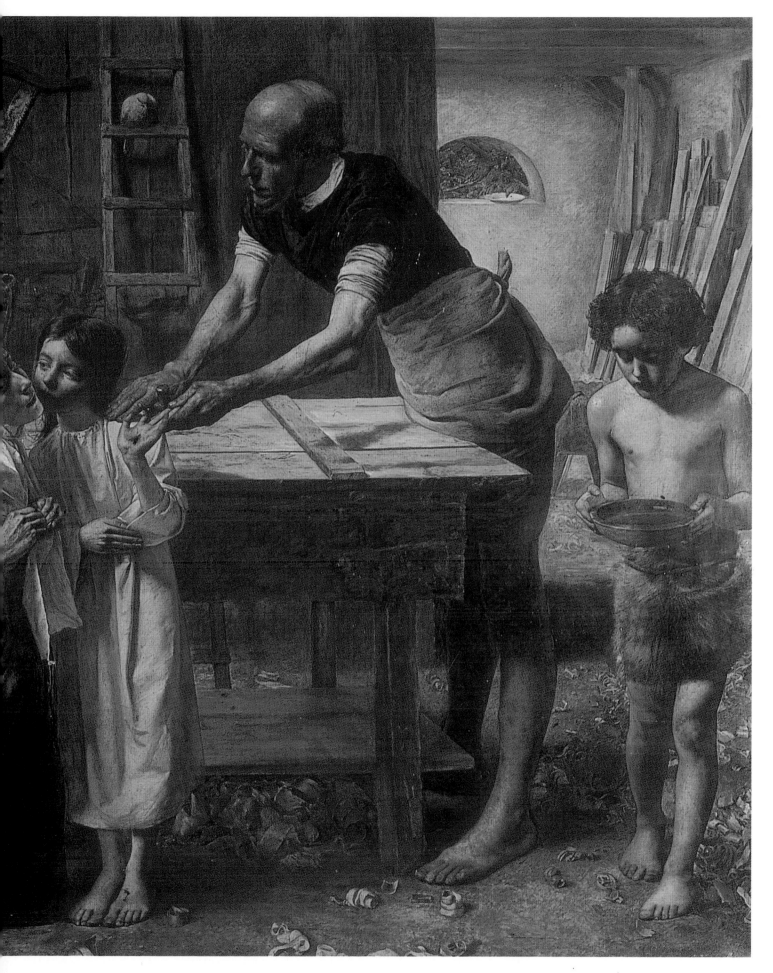

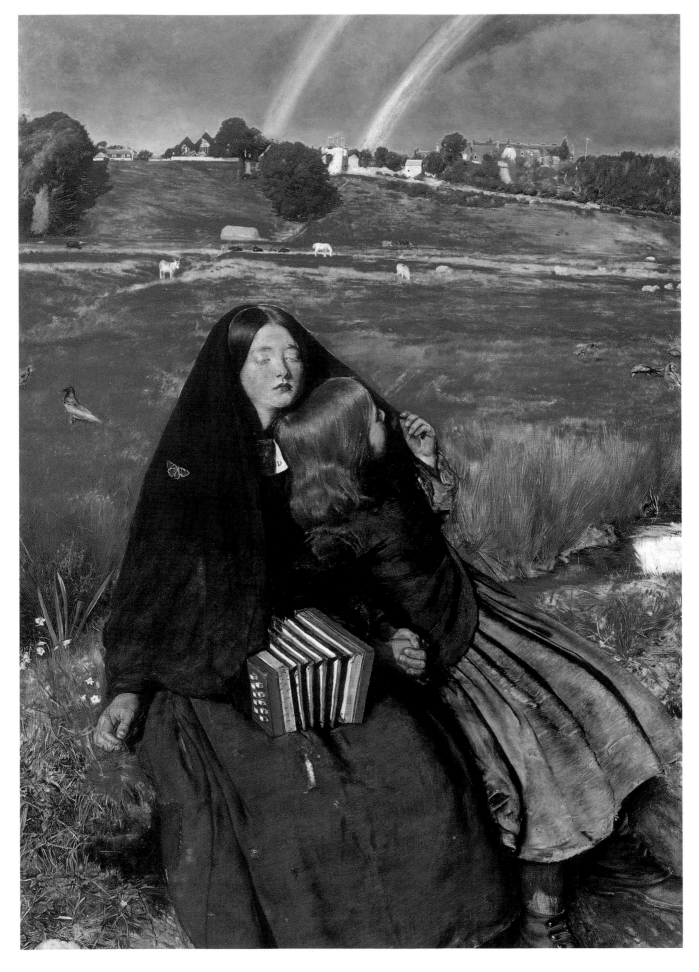

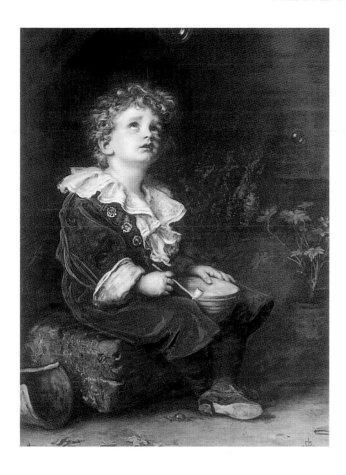

PLATE 19 left
Bubbles (Poster for Pears' Soap) 1886
John Everett Millais

Millais had been an infant prodigy, but his later work shows signs of degeneration from its early promise and a large number of portraits and many excessively facile and sentimental paintings were produced. After his marriage, and with a fast-growing family, Millais was obliged to work hard at portraiture as well as more popular commercial subjects, such as his famous Bubbles, *in order to support an increasingly busy social life. His later financial and artistic success was considerable – he could earn £30,000 a year, an enormous sum at the time. All this, however, has nothing to do with Pre-Raphaelitism and not all of his portraiture is as bad as it is often said to be; its technical quality is often very high indeed.*

PLATE 18 opposite
The Blind Girl (1856)
John Everett Millais

Oil on canvas, 32¹/2 x 24¹/4 inches (82.6 x 61.6cm)

Most Pre-Raphaelite paintings are carefully placed in identifiable locations, suggested either from correspondence or by actual places. This painting is a view of Winchelsea in Sussex which Millais had visited with Holman Hunt and Edward Lear in the summer of 1852 and the bright open landscape is in sharp contrast to the huddled figure of the blind beggar girl. Clues to the intended message, that of the social deprivation of vagrant children, abound in the painting. The rainbow indicates one of the natural pleasures of sight denied to the girl whose faculties are otherwise unimpaired, and shown by the concertina and her hand feeling the grass. The models were the same as those used in Autumn Leaves *(plate 3), and were discovered for Millais by Effie, his wife.*

accomplish almost anything that he attempted, there remained little to challenge his talent. For a short time, however, his interest was stimulated by the Pre-Raphaelite Brotherhood and it was during this period that his talent was harnessed to a cause in which he could believe. There is little doubt that during this time he was an enthusiastic believer in the same artistic ideals that motivated Hunt and Rossetti. But when this restraint and direction was removed, his work failed to retain many of these qualities.

His first Pre-Raphaelite painting was *Lorenzo and Isabella* (plate 16), which he signed, adding the PRB logo, and which illustrated a scene from Keats' poem *Isabella*. In the next year, 1850, his first controversial painting *Christ in the House of His Parents* (plate 17) aroused literary fury in Charles Dickens leading him, in his weekly *Household Words*, to describe the work as 'a pictorial blasphemy, mean, odious, revolting and repulsive'. Two years later Millais finished *Ophelia* (plate 20), an essentially Pre-Raphaelite image in its precision of detail and unified into a image of memorable distinction. The choice of subject indicates a source from which many Pre-Raphaelites drew – the works of William Shakespeare. The model for this painting was Elizabeth Siddal, who later married Dante Gabriel Rossetti. In order to lend a sense of reality to the pose, she was obliged to lie, in full costume, in a bath of cold water through which she

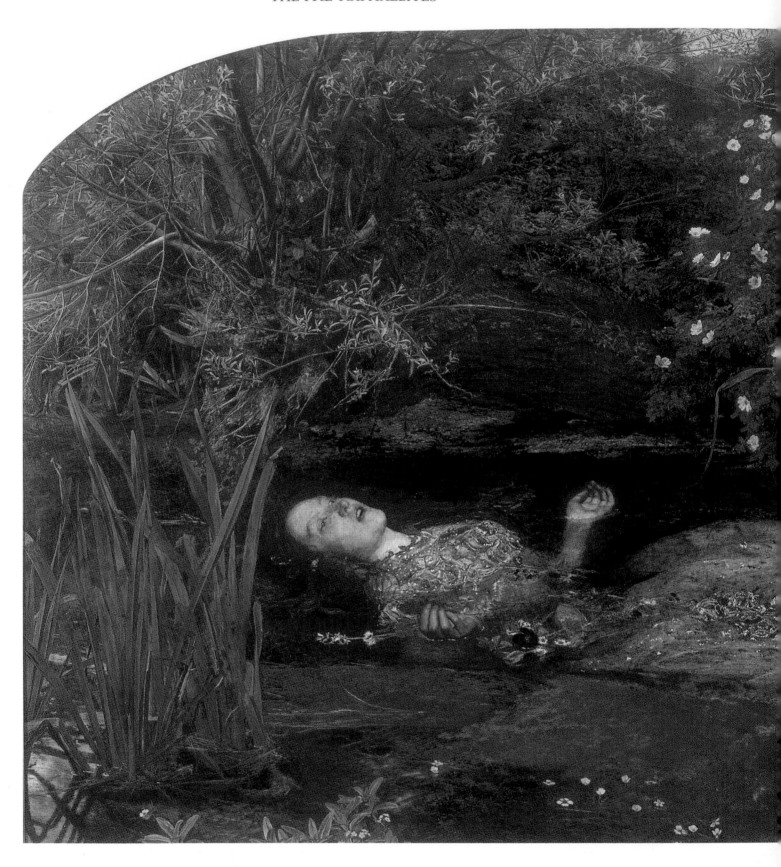

contracted a serious lung infection which greatly affected her
general health and probably contributed to her early death.

A significant event occurred in 1856, unrecognized at
the time. Millais was elected an Associate Royal
Academician. Although that year he had produced one of

his finest Pre-Raphaelite works, *The Blind Girl* (plate 18), it
was effectively the end of his association with the
Brotherhood's aims and the beginning of 'another life,
another time'. Unconsciously but progressively, his work
moved further towards commercialism and although his

PLATE 20
Ophelia (1852)
John Everett Millais
Oil pastel on paper, 30 x 44 inches (76.2 x 111.8cm)

Victorian painters were devoted to subject-matter from Shakespeare and for the Pre-Raphaelites he was a natural inspiration for the detailed observation of nature combined with poetic symbolism. Painters could also assume that the educated viewers of their work would be fully aware of the source. The story of the death of Ophelia became one such subject after Millais painted the first, and most admired, treatment. The model was Elizabeth Siddal who posed fully dressed in an old gown specially purchased by Millais reclining in a bath heated from underneath with oil lamps. It is related that on one occasion the lamps went out, Elizabeth caught a severe cold and her irate father forced Millais to pay the doctor's bills. It has also been suggested that the experience weakened her general health and contributed to her early death through an overdose of laudanum to which she had become addicted. William Michael Rossetti, Dante Gabriel's brother, believed this to be the best likeness of Elizabeth ever painted. As might be anticipated, the painting is full of Shakespearian references and the details of the flowers and other plants is scrupulously observed. It has been suggested, for instance, that the robin in the upper left corner refers to Ophelia's song, 'For bonny sweet Robin is all my joy'.

which is revealing of many aspects of mid Victorian life and society. John Ruskin was married to a distant cousin, Euphemia (Effie) Gray, and invited Millais to accompany them on a trip to Switzerland. Although he declined, he did agree to join them on a trip to Scotland in 1853. They stayed at Glenfinlas and Millais began a full-length painting of Ruskin by the Falls (plate 8) and Millais' detailing of the rocks reflected Ruskin's interest in geology. The result is one of the finest 19th-century portraits; but there is a twist to the tale in that at the same time Millais began an affair with Effie. Her marriage was unhappy, had not been consummated, and she subsequently left Ruskin and married Millais. It is interesting to note that, although this would normally be expected to be the end of their relationship, this was in fact not the case and Ruskin continued to support Millais after his separation from Effie and, indeed, seemed happier as a result. Another painting of 1853 was *The Order of Release* (plate 9), in which the

success continued, and in the last year of his life he became President of the Royal Academy, he had effectively again lost his way.

There is a well known but strange story which arose during the later stages of Millais' Pre-Raphaelite association

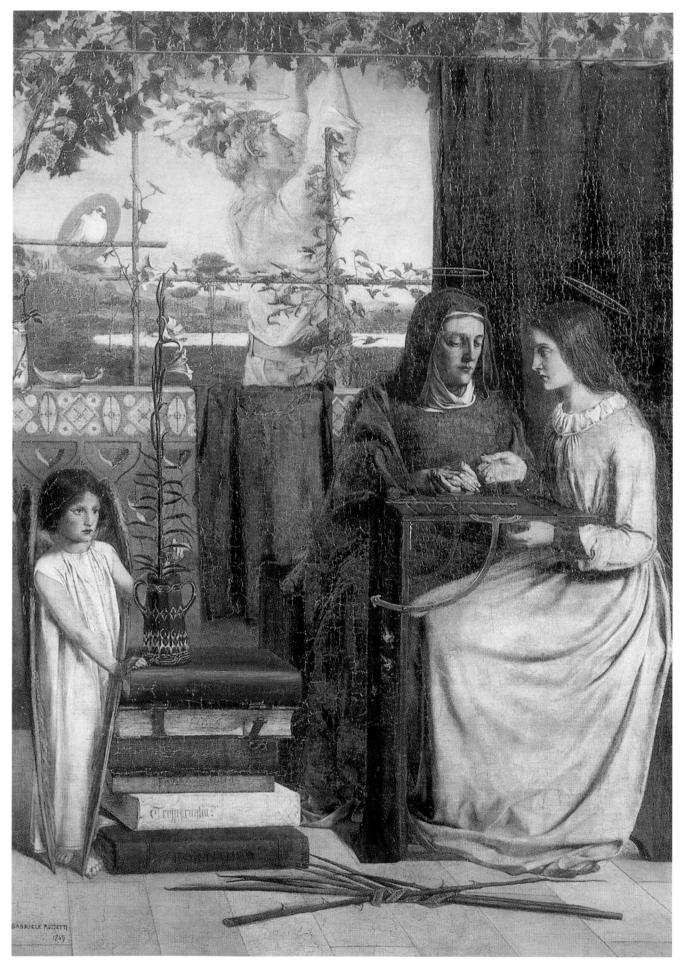

PLATE 21 opposite
The Girlhood of Mary Virgin (1849)
Dante Gabriel Rossetti
Oil on canvas, 32³/4 x 25³/4 inches (83.2 x 65.4cm)

Rossetti was the first to use the PRB initials in his first important painting exhibited in the Free Exhibition of 1849. The painting was begun in the summer of the previous year and work progressed slowly so that, by the end of the year, he had only painted the background. His method, as William Bell Scott records, was to use watercolour brushes to paint in oil which resulted in a thin transparent colour effect, intended to emulate the 'primitives'. The model for the Virgin was Rossetti's sister Christina, while the head of St. Anne was a portrait of his mother. The painting is full of more obscure symbolism than is common in the work of Rossetti's contemporaries and, although it is not possible here to elaborate an examination of these, it may be noted that the compositionally significant books represent, in symbolic colours, the virtues; the vine, tended by St. Joseph, refers to the coming of Christ and the lamp appears as an emblem of piety. The haloed dove symbolizes the Holy Spirit. The painting was admired at the exhibition and was sold for 80 guineas.

PLATE 22 right
Ecce Ancilla Domini (The Annunciation) (1849–50)
Dante Gabriel Rossetti
Oil on canvas, 28¹/2 x 16¹/2 inches (72.4 x 41.9cm)

As indicated in the introduction, Rossetti had none of the natural facility of Millais or the tenacious dedication of Hunt. His contribution was a poetic lyricism accompanied by an ability to create dramatic and affecting images of subjects usually treated very differently. As his brother William said of the origins of this painting: 'Gabriel began making a sketch for the Annunciation. The Virgin is to be in bed, but without any bedclothes on, an arrangement which may be justified in consideration of the hot climate, and the Angel Gabriel is to be presenting a lily to her. The picture ... will be almost entirely white.' Rossetti has used white as the colour of purity and the red cloth which the Virgin had been working on in the earlier painting, The Girlhood of Mary Virgin *was the colour for Christ, while blue is associated with Mary. The painting was first exhibited in 1850 at the National Institution and received considerable criticism, both for the weakness of the drawing and its didactic approach. The* Athenaeum *critic wrote of the 'presumption of a teacher'. The painting was not sold and Rossetti continued to work on it and would not exhibit again in London.*

female model was also Effie Gray.

The marriage flourished, a large family resulted, and Millais was obliged to work hard at portraiture as well as more popular commercial subjects, such as his famous *Bubbles* (plate 19), in order to support an increasingly busy social life. His later financial and artistic success was considerable – he could earn £30,000 a year, an enormous sum at the time. All this, however, has nothing to do with Pre-Raphaelitism and it would be inappropriate and misleading to pursue the matter here. Indeed, his later work has none of the controlled quality and sense of direction of his Pre-Raphaelite period.

DANTE GABRIEL ROSSETTI (1828–1882)

Rossetti's father, Gabriele Rossetti, was an Italian political refugee, having been obliged to flee the country as a result of his participation in the insurrections of 1820 and 1821. He was a man of considerable and, it appears, varied talents since even before he left Italy he had successively been a

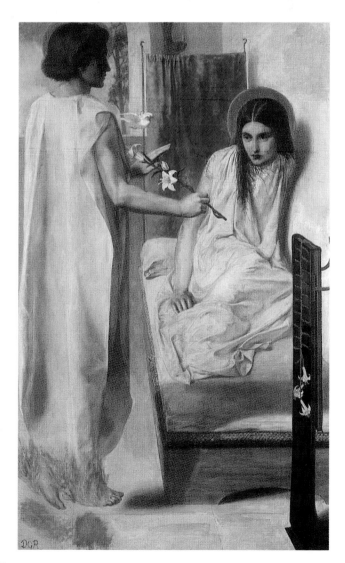

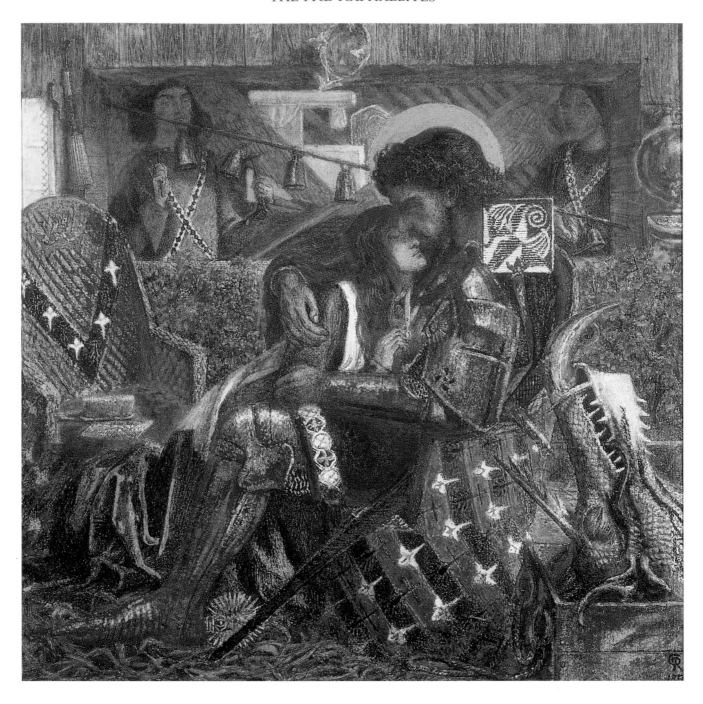

librettist for the opera house in Naples and curator of antiquities in the Naples Museum. He came to England in 1824 where he established himself as a teacher of Italian and was subsequently appointed Professor of Italian at King's College, London. He was a poet and a devoted scholar of Dante. In 1826 he married a private teacher who was of both Italian and English extraction and there were four children of the marriage. Maria Francesca, the eldest child was deeply religious and entered an Anglican sisterhood where she died in 1876 before she was 50. Nevertheless, she left behind an important essay on Dante still valued by scholars. Dante Gabriel was the second child and William Michael, who became a member of the Brotherhood, was

the third. The last child was Christina Georgina, who became a well known poet. Gabriele was a fervent patriot who is best remembered for his literary attempt to establish an anti-papal significance in Dante's *Divine Comedy*.

The Rossetti children thus grew up in an intellectual family with literary, political and artistic pretensions. Dante Gabriel was a precocious youth, given to writing dramatic scenes at the age of five or six. But it was towards art that he was drawn and it was in about 1840–41 that he entered the drawing academy of Henry Sass where he spent most of his time reading and illustrating scenes from Shakespeare, Byron and Walter Scott. In 1844 he entered the Royal Academy Schools as a probationer, becoming a full student

PLATE 23

The Wedding of St. George and the Princess Sabra (1854)

Dante Gabriel Rossetti

Oil on canvas, 13½ x 13½ inches (34 x 34cm)

One of the finest of Rossetti's paintings and completed during his close attachment to the romantic rather than historical or religious aspects of medievalism, this work reveals his watercolour style, different from the usual treatment of the method, as a carefully and densely constructed surface as might have been made in oil painting

technique without the thickness and opacity of that medium. The resulting image has a freshness and authority which is special to Rossetti whose talent was more poetic than technical. In this painting the head of the slain dragon may be seen in a coffin box in the bottom right corner while Princess Sabra, held tightly in St. George's protective arms, is cutting off a lock of her hair which she has wound into a loop in his armour as a gift favour. One viewer wrote that the watercolour was 'one of the grandest things, like a golden dim dream' – a reflection of the medievalist passions then current.

a year later. He was a pupil of Ford Madox Brown for a few weeks in 1848 before he moved with Holman Hunt to a studio where, later in the year, the Pre-Raphaelite Brotherhood was formed. It is evident that his enthusiasm and intellectual background made him the actual driving force in the enterprise but he had less natural painting ability than either Hunt or Millais and found it a struggle to find an effective technique. It is only later that his importance in forming the character and philosophy of the Brotherhood becomes evident in his work, his first major oil painting, *The Girlhood of Mary Virgin* (plate 21), being shown in March 1849. His contribution to the Brotherhood included the main responsibility for its short-lived magazine, *The Germ*.

In 1850 Rossetti exhibited *Ecce Ancilla Domini* (plate 22) at the National Institution and the antagonistic reception it received from the critics so discouraged him that he rarely showed his work in public thereafter. John Ruskin, who had defended the Pre-Raphaelites in 1851 and had become friendly with both Hunt and Millais, did not meet Rossetti until 1854 but became his friend, a demanding patron and a forceful critic. This association was an important one for Rossetti and provided the opportunity for wide contacts in the literary and artistic world of mid Victorian England. In 1860 he married Elizabeth Siddal whom he had met in about 1849 and who had been Millais' model for *Ophelia* (plate 20). His main

model and mistress from about 1858 was, however, Fanny Cornforth, and he was deeply attracted to Jane Burden who was William Morris's wife. The Brotherhood, it might be said, had an attendant sisterhood who provided strong emotional support of an unconventional nature rarely acknowledged at that time in Victorian England.

During his life, Rossetti was engaged in literary activity and published volumes of poetry as well as making translations from the Italian poets – *The Early Italian Poets* was published in 1861. It is important to recognize that Rossetti remained a literary as well as an artistic figure in the cultural circles of the day. Indeed, he was the least naturally talented painter of the group although he is better known as a painter than as a poet. He was a friend of many of his literary contemporaries. In 1862, his wife Elizabeth died from an overdose of laudanum and later in the year Rossetti moved to an address in Cheyne Walk in London's Chelsea, which he shared for a time with Algernon Charles Swinburne, and for a brief period with George Meredith.

After his wife's death, Rossetti's association with Jane Burden Morris became more intimate and she frequently modelled for him, as also did Alexa Wilding whom he met in 1865 (see plate 7). During the next years he began increasingly to suffer from physical problems beginning with eye trouble which led to insomnia and emotional problems and eventually, in 1872, to a breakdown. He became increasingly reclusive, dependent on laudanum,

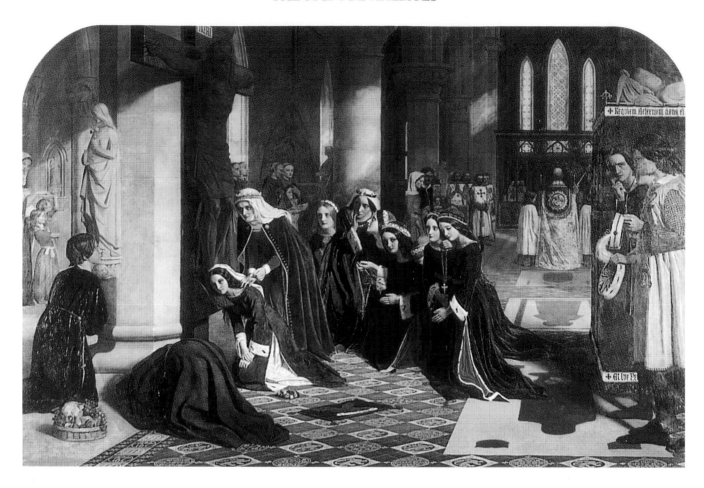

and severed relationships with friends, Swinburne among them, seeing few apart from Madox Brown, his early teacher and closest associate. He spent much of his time at Kelmscott, the country house in Wiltshire owned by William Morris. A new edition of his *Poems* was published in 1881 and, despite his basically strong constitution and the fact that he had managed to wean himself from his laudenum habit, he died, his health broken, in April 1882.

Despite Rossetti's lack of natural facility, his determination and intellectual ability enabled him to construct an *oeuvre* of great distinction and interest. He is a figure of unique qualities in the field of English art, being now equally celebrated as poet and painter. His unconventional attitude to the strict public morals of the Victorian age reflects one important element of Pre-Raphaelitism – its perception of itself as revolutionary and in the expression of this perception Rossetti, with his Italian background, was perhaps the leading force. It is surely no coincidence that the Brotherhood was formed in the so-called Year of Revolutions. Although Britain saw none of the upheavals found in other European states, the Chartist movement, which had inspired Hunt and Millais, was a reflection of the revolutionary spirit then current. Rossetti

possessed natural energy and was essentially an intellectual with a refined mind and creative sensibilities more original than his associates. However, he lacked the natural facilities of Millais or the dedicated physical determination of Hunt. Despite this, he remains the most complicated and original spirit in the Brotherhood and his poetry is one of the most significant expressions of its spirit: without it, Pre-Raphaelitism would be seriously diminished.

JAMES COLLINSON (1825–1881)

It cannot be said of Collinson that he was a highly important member of the Brotherhood but he was indeed one of 'the seven', having become acquainted, it is believed, with the three central figures while a student in the Royal Academy Schools. At all events, he became engaged to Christina Rossetti and was proposed by Dante Gabriel for membership in 1848. There is a vagueness in his background but he was apparently born in Mansfield, near Nottingham, in the English Midlands, the son of a sub-postmaster and bookseller. He came to London sometime before 1847 when he exhibited at the Royal Academy. He contributed to *The Germ* but in 1850 his engagement to Christina was broken off and he resigned from the Brotherhood.

PLATE 24 opposite
The Renunciation of Queen Elizabeth of Hungary (1850)
James Collinson
Oil on canvas, 47³/8 x 71¹/2 inches (121 x 181.6cm)

Collinson's less than decisive commitment to Pre-Raphaelitism resulted in few works that could be related to the intentions of the movement and even this painting, closest in character, is hardly rigorous in treatment. The subject of Queen Elizabeth, married to King Louis IV of Thuringia and made Regent after his death in a Crusade, was a reasonably appropriate one for Pre-Raphaelite treatment. She was deposed, renounced her throne, retired to a convent and was later canonized. This 13th-century romance was of the right period and possessed of strong sentimental content but Collinson managed to bring it into the 19th century, setting it in an evidently Victorian Gothic interior, and with a groomed film-set quality.

PLATE 25 below
Mother and Child (c. 1854)
Frederic George Stephens (1828–1907)
Oil on canvas, 18¹/2 x 25¹/4 inches (47 x 64.1cm)

Although the painting as presented here has an arched top the canvas is rectangular and Stephens had originally extended the design to cover the whole. The only part painted was as shown here. Stephens very soon abandoned painting and although this is an interesting painting it reveals the difficulty that he encountered in creating effective perspectival space. At first sight the work seems to be a simple domestic scene but there is a dramatic and tragic theme to be discovered. The first clue is the lion and the hussar which reveal that the real subject is the Crimean War which had begun in March 1854. The mother is holding a letter which suggests the death of her soldier husband and the look of pain on her face and the urgent action of the child confirm the clues. Meticulous in painting, it nevertheless does not show the conviction which his fellow Brothers offer and partially at least accounts for his abandonment of painting.

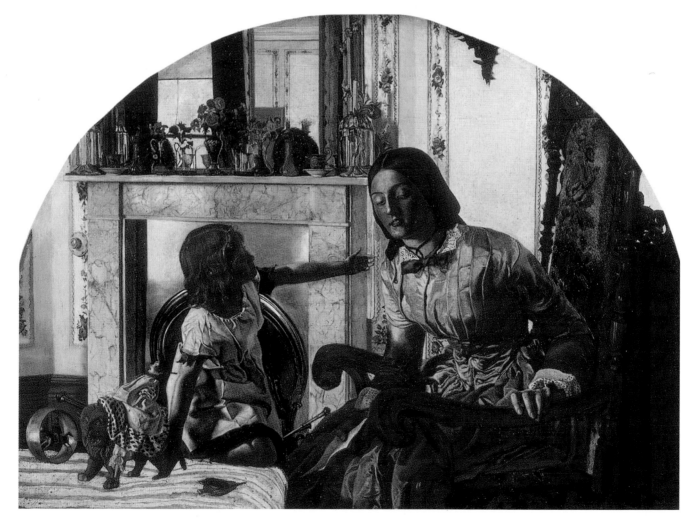

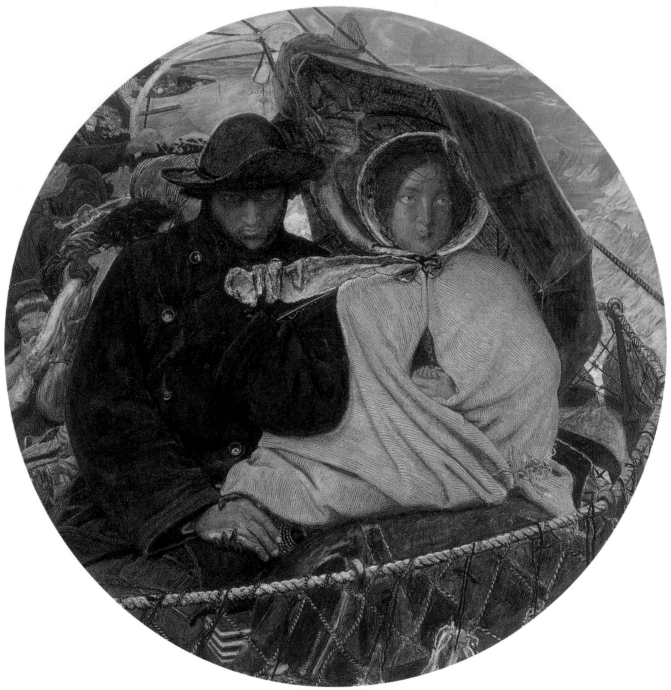

PLATE 26
The Last of England (1855)
Ford Madox Brown
Oil on panel, 32¹/₂ x 29¹/₂ inches (82.5 x 75cm)

*Begun in 1852 but signed 1855 and one of Brown's most
significant works, this depicts Thomas Woolner's departure from
England in 1852, bound for Australia to mine for gold. Hunt and
Rossetti saw Woolner's departure with his family and although
there is no positive evidence of Brown's presence on the occasion, the
painting saw a change in his fortunes when it was completed in
1855. Brown himself had been despondent at his lack of success
and had contemplated emigration to India; but the immediate sale*

*of this painting prompted a new optimism and the abandonment of
the idea. Brown may have been directly inspired to paint the subject
by Woolner's departure but his description of his intention in a later
catalogue indicates that it is the feelings aroused on abandoning
one's native land rather than the physical actuality which inspired
the idea. He says: 'I have tried to render this scene as it would
appear. The minuteness of detail which would be visible under such
conditions of broad daylight, I have thought necessary to imitate, as
bringing the pathos of the subject more home to the beholder.' The
models for the two central figures were his wife Emma and himself
and their children, Katty and Oliver, the child with apple and the
baby whose hand only is seen, emerging from Emma's cloak.*

He was much involved with religion, which was always uppermost in the minds of the Pre-Raphaelite Brotherhood and sponsored much of the painting of its members. He joined the Roman Catholic Church, resigned when he became engaged to Christina, rejoined when the engagement was broken off and claimed that membership of the Brotherhood was incompatible with his faith. He then joined the Jesuit house of Stoneyhurst in Lancashire to train for the priesthood but left without completing his novitiate and resumed painting. He remains, in consequence, a somewhat ephemeral character whose work actually had little in common with the principles of the Brotherhood. His characteristic subjects were genre scenes with a message and his best known PRB painting is *The Renunciation of Queen Elizabeth of Hungary* (plate 24).

THOMAS WOOLNER (1825–1892)

Woolner can be regarded as what would now be described as the 'token' sculptor of the Brotherhood. After some discussion it was agreed that sculpture could be included within the Brotherhood's philosophy of art and he was consequently accepted as a member.

He was born in Suffolk and was a member of the Royal Academy Schools in 1842. He was introduced to Hunt and Millais by Rossetti. A poet as well as a sculptor, he was associated with several literary figures of the day, being a friend of Coventry Patmore and Alfred Tennyson, both of whom he sculpted and induced to contribute to *The Germ*. His career in sculpture did not flourish and he emigrated to Australia – to dig for gold! This proved even less profitable and he returned to England where he gradually built a sculpture and design practice, particularly in portrait busts and full-length figures. His subjects included Gladstone, Carlyle, Cardinal Newman and Cobden. He was made A.R.A, R.A. and Professor of Sculpture at the Royal Academy Schools.

Woolner cannot be seen as an important figure in the Brotherhood and his work does not establish, in either quality or intention, the essential appropriateness of sculpture to the movement. Indeed, his closest association with the spirit of Pre-Raphaelitism is found in the painting by Ford Madox Brown, *The Last of England* (plate 26), for it was he and his family who provided the inspiration as they left for Australia.

The remaining members of the Brotherhood, Frederic George Stephens (1828–1907) and William Michael Rossetti (1829–1919) were, as has already been indicated, more apologists and supporters than participants in its artistic output. Nevertheless, each had his importance to the movement. Stephens went through training at the Royal Academy Schools where he met Hunt, who nominated him for the Brotherhood, and he began a painting career which did not succeed. He found difficulty in completing his works and failed almost entirely to have them exhibited. He abandoned painting and turned to writing and art criticism, contributed to *The Germ,* and became art critic to the *Athenaeum* magazine for 40 years. He also wrote a number of books on other painters, including Sir Edwin Landseer.

THE FOLLOWERS

Some of the best known works associated with Pre-Raphaelitism were painted by the associates or followers of the Brotherhood, two of whom, Ford Madox Brown and Edward Burne-Jones, are always perceived as being members and creative figures in the aims of the movement. Other important contributors to be considered and included are Arthur Hughes, John Brett, Walter Howell Deverell, William Dyce, John William Waterhouse, Robert Braithwaite Martineau and, more marginally, William Morris and other lesser figures.

FORD MADOX BROWN (1821–1893)

The eldest of the Pre-Raphaelite associates, Brown received a thorough artistic training in the academic tradition. He was born in Calais and studied in Bruges and Ghent under two pupils of Jacques-Louis David, the great Neo-Classical painter during the French Revolution and later during the Napoleonic period, who died in Belgium in 1825. He completed his studies in the Antwerp Academy and moved to Paris in 1840 where he studied the great masters and French contemporaries including Eugène Delacroix. He moved to London in 1844, embarking on a short-lived marriage to his cousin who died only two years later. In 1848 he became acquainted with Rossetti who went to him for lessons and the meeting resulted in a lifelong friendship which powerfully influenced Rossetti's painting. In turn, Brown was influenced by the Brotherhood's ideas and two of his most important works, *The Last of England* and *Work* (plate 27), are very much in the spirit of Pre-Raphaelitism. In both these paintings Brown's second wife, Emma Huill, is portrayed.

In 1861 he became a founder member of Morris, Marshall, Faulkner and Company, the famous decorating firm formed under the creative energy of William Morris, for which he designed furniture and stained glass. By this time, despite early failure (partly due to the dismissive

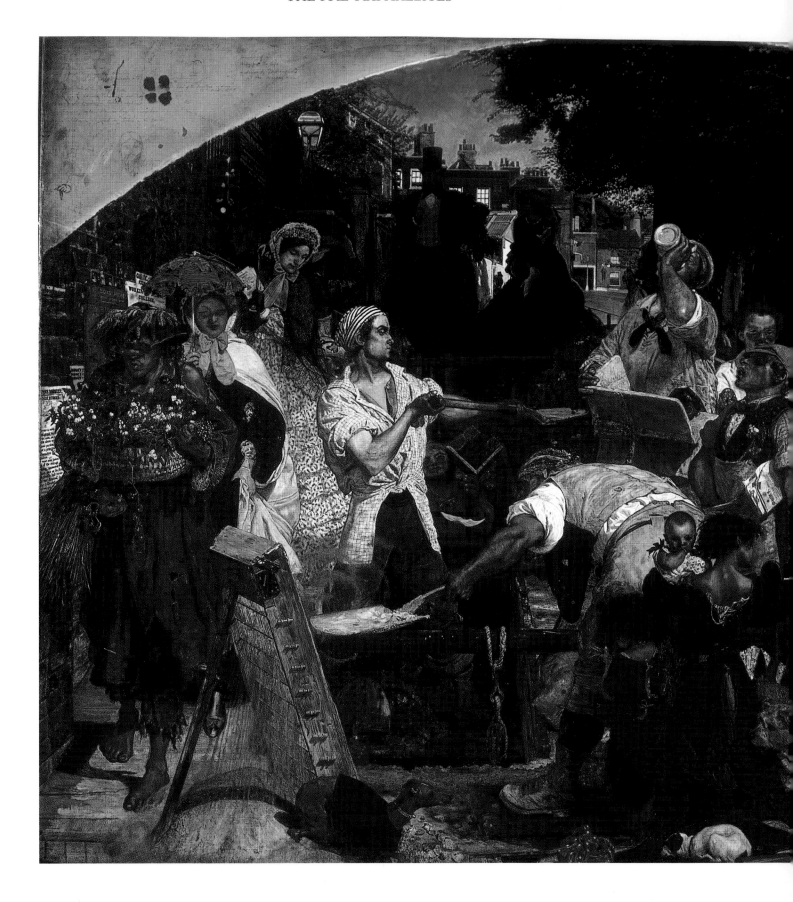

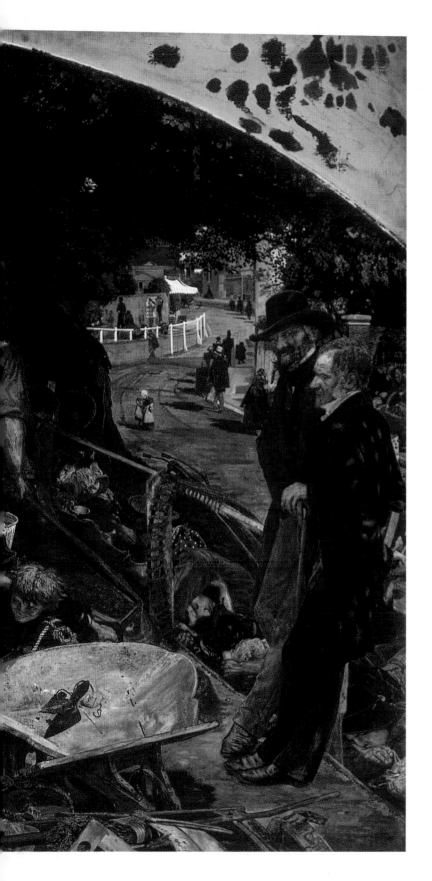

antagonism of John Ruskin) which weakened his health and resolve, he had become increasingly successful with portraits and subject paintings which he often replicated. His last great commission was for the murals in Manchester Town Hall, recounting the history of the city. These occupied much of his last years and he lived in Manchester for a time in order to complete them. He died in London in 1893.

PLATE 27
Work (1852–1865)
Ford Madox Brown (1821–1893)
Oil on canvas, 53 x 77^1/$_8$ inches (134.6 x 195.9cm)

This is one of three paintings of the subject begun in 1852 and the last to be completed. The location is Heath Street, in Hampstead, an outskirt of London and near to the artist's own home. The work was inspired by the street workmen, 'navvies', who form the central motif of the painting. Perhaps the most significant single figure is that of Thomas Carlyle, depicted on the right and looking out towards the viewer.

Brown was a great admirer of Carlyle's writings and particularly of his Past and Present, *1843, with its concern for social problems. The painting is an intensely symbolic work, showing the various 'classes' of society playing out their roles. The apex of the painting and the social scale are the two dark figures on horseback. The road is blocked and the daughter says 'We must go back, Papa, round the other way', as the catalogue states. Each element, if examined carefully, has a symbolic social message. The wall on the left carries a poster for the Working Men's College (at which Brown taught from about 1857 and with which Ruskin was also involved) and the billboard walkers in the right distance carry the name of Bobus from* Past and Present. *Standing next to Carlyle is F. D. Maurice, another great social reformer. One could pursue the subject if space allowed but it is perhaps significant to note that the painting, now much revered, was not greatly considered at the time and remained in a private collection until 1883 when it reappeared on the breakup of its owner's estate and was bought by the Manchester City Art Gallery.*

PLATE 28
Panel from The Briar Rose:
The Sleeping Beauty (1871–1890)
Edward Coley Burne-Jones
Oil on canvas, 28^1/2 x 71^3/4 inches (72.4 x 182.3cm)

Based upon the famous story of the Sleeping Beauty, Burne-Jones'
series of four large panels, known as the Briar Rose series, since the
flower appears in all the paintings and a briar wood is central to the
story, is the most important and best known cycle by him. Now
located at the country house, Buscot Park near Faringdon in
Berkshire, England, having been bought by Alexander Henderson,
the first Lord Faringdon, the initial inspiration originated with a set
of ceramic tiles that Burne-Jones designed to illustrate the story
which he then followed with three small oil paintings following
these, starting in 1871 with the Briar Rose paintings. The other
three paintings are 'The Prince Entering the Briar Wood', 'The
King and his Courtiers Asleep', A Group of Servants Asleep'.
Burne-Jones later added a number of small decorative panels to form
a running frieze.

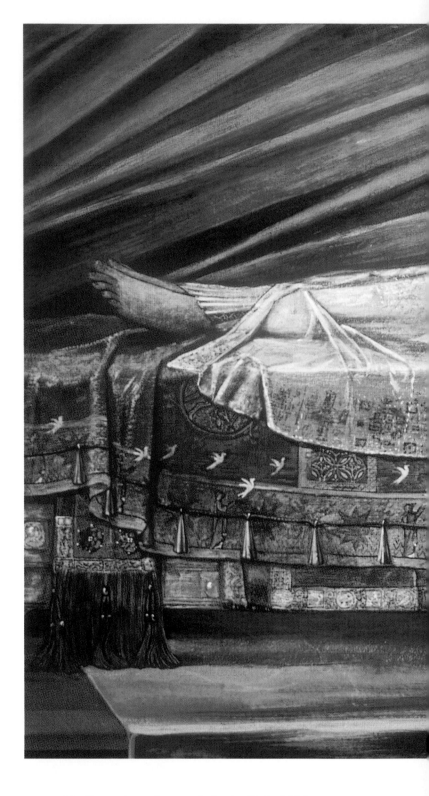

EDWARD COLEY BURNE-JONES
(1833–1898)
Although never a member of the Brotherhood, with his
distinctive intelligence and strong Christian faith (an
important element in the Pre-Raphaelite philosophy), it
seems in retrospect that throughout his working life he
epitomized the qualities of the movement to a far greater
extent than either Millais or Madox Brown.

His early intention was to enter the Church but it was at
Exeter College, Oxford that he met William Morris, with
whom he formed a deep and lifelong friendship. Together
they decided to devote their lives to art after studying the
works of John Ruskin who, in the 1850s and despite his
youth, was becoming the first popular authority on art and
aesthetic judgement (he was born in 1819) and subsequently
became the most powerful art critic of his day. His later
defence of the Pre-Raphaelites was a potent influence in
their acceptance although he had not at that time met them.
Burne-Jones also met Rossetti in 1856 after leaving Oxford
and took some lessons from him; but he was, as a painter,
effectively self-taught although he was one of the painters

engaged by Rossetti to paint murals for the Oxford Union.
His work at this time shows the influence of Rossetti. Like
Ford Madox Brown he was one of the founders of the
Morris company, mentioned above.

It was only in the 1860s that he evolved the
extremely effective personal style which, in spirit but
not in technique, was close to Pre-Raphaelitism. It is
difficult to see the work of Burne-Jones and Millais or
Hunt as part of the same movement unless one recalls

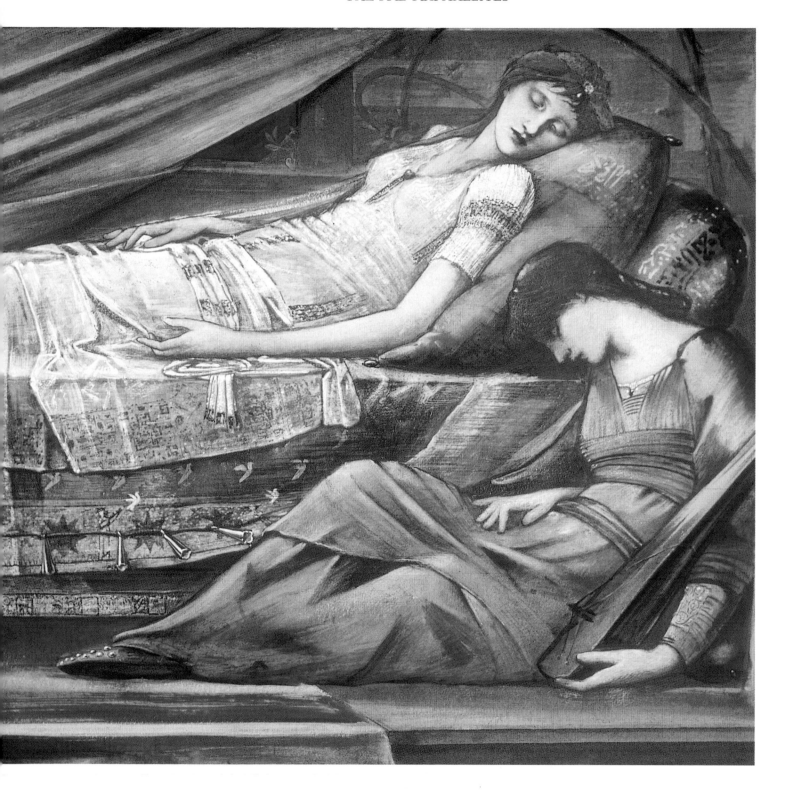

the deep spiritual and medievalist enthusiasms of the Brotherhood. Like Ford Madox Brown, and with greater effectiveness, he made designs for stained glass for the Morris firm and became widely admired by a few discriminating patrons. In 1867, married and with two children, Burne-Jones settled in Fulham, London. After a period of obscurity he was returned to a greater fame as the result of eight paintings he submitted to the opening of the Grosvenor Gallery, London, which secured him a

central place in the Aesthetic Movement. His reputation grew through his continued participation in Grosvenor Gallery exhibitions and culminated in his *Briar Rose* paintings exhibited in Agnew's Gallery, London, in 1890. He was knighted in 1894, at that time a rare distinction for an artist and an indication of acceptance by the Establishment. He was engaged in his later years on illustrations for William Morris's Kelmscott Press, the most famous of which was his *Chaucer* (1896).

PLATE 29
King Cophetua and the Beggar Maid (1884)
Edward Coley Burne-Jones

Oil on canvas, 115$^{1}/_{2}$ x 53$^{1}/_{2}$ inches
(293 x 136cm)

Burne-Jones is a figure who inevitably appears in any book on the Pre-Raphaelites and he is frequently seen as one of its central figures, although the Brotherhood had ceased to exist while he was an undergraduate at Exeter College, Oxford, having gone up in 1853. However, he was a friend of the members of the original Brotherhood through Rossetti and became a close associate of William Morris, being responsible for the decorations to Morris's famous Kelmscott Press volume of Chaucer. Perhaps his association with the movement is assisted by the early development of his highly personal style and its influence on his contemporaries, as well as placing him in a central role in the development of the Aesthetic Movement.

Although a later work, his most celebrated painting is illustrated here as a fine example of his style, as personally distinguished from Rossetti's. An Elizabethan ballad is the original source for the subject which depicts the love of a king for a beggar maid (used also by Tennyson in his poem 'The Beggar Maid') and his eventual marriage to her. Here he sits below her, lost in evident admiration as she gazes apprehensively forward into the future. Burne-Jones' technique of strong forms and tonal contrasts is seen here to full effect, as is the curious eroticism of his female figures.

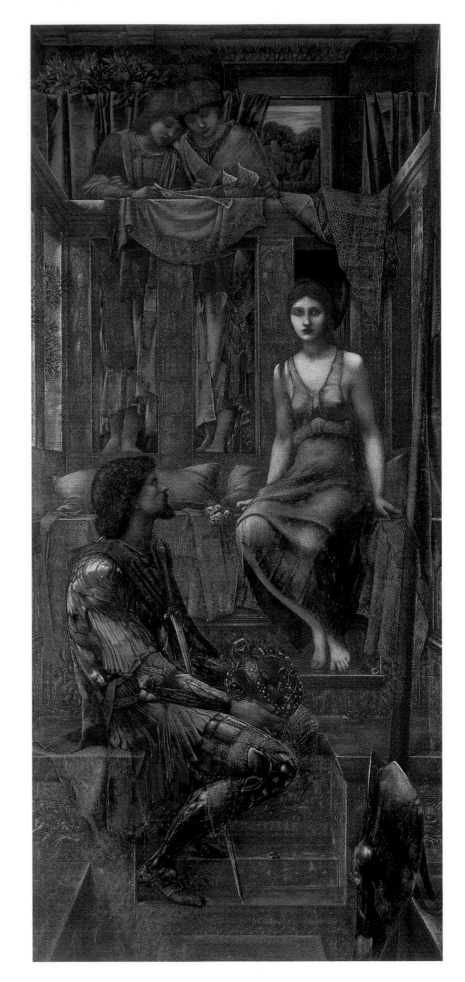

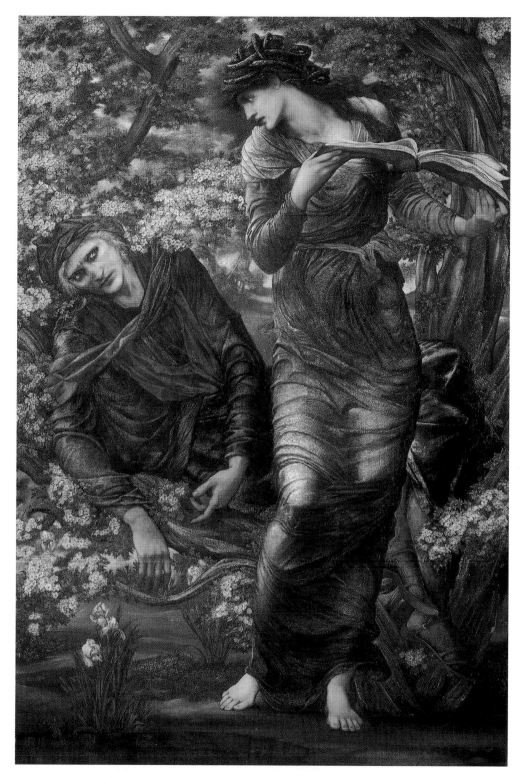

PLATE 30
The Beguiling of Merlin (1874)
Edward Coley Burne-Jones

Oil on canvas, 73 x 43³/4 inches (186 x 111cm)

One of the earliest books printed in Britain by Caxton in 1485 was Sir Thomas Malory's Morte d'Arthur, *interconnected stories of King Arthur and his Round Table which began a national passion for the romantic and mystical episodes described, interest in which*

endures to this day. During the 19th century, Tennyson published the Idylls of the King, *stimulating a new interest in which the Pre-Raphaelites participated.*

Merlin, King Arthur's guru, imbued with great mystical powers and who knows the past and future, is lulled into a deep sleep by the enchantress Vivien or Nimue (Nimiane) in a hawthorn copse in the forest of Brocéliande. Derived from a medieval tale, recounted in Malory, and described in the Idylls, *it was a natural choice for Burne-Jones, for whom the subject held a particular interest.*

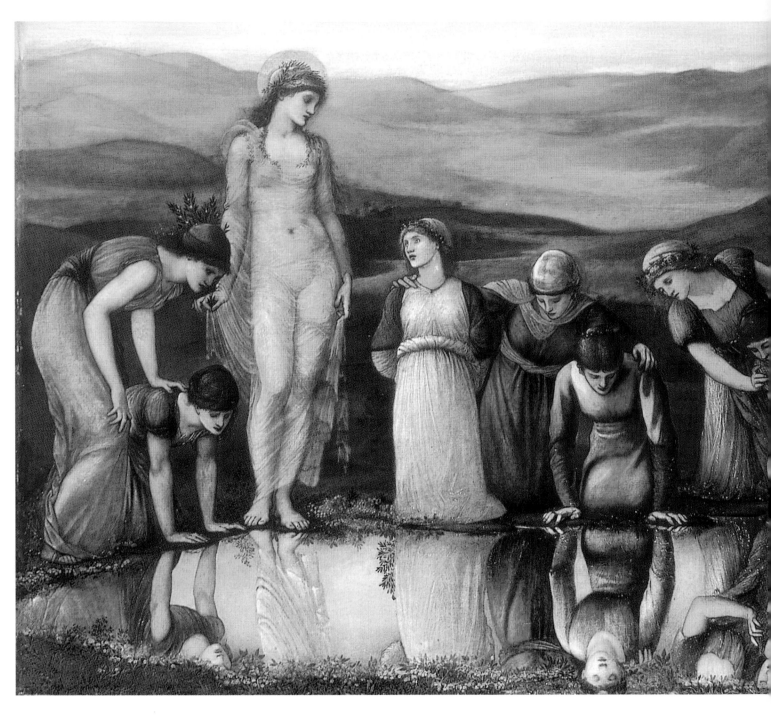

PLATE 31 above
The Mirror of Venus (1877)
Edward Coley Burne-Jones
Oil on canvas, 47^{1}/$_{4}$ x 78^{3}/$_{4}$ inches (120 x 200cm)

*The extraordinary individuality of Burne-Jones' work can be seen
at its most effective in this curiously unfocused work which seems to
be concerned with a vague idyllic and atmospheric scene of no
specific subject. Although called* The Mirror of Venus, *it seems to
carry no clear subject message; indeed were it not for the striking
similarity to Botticelli's Venus it would be difficult to identify her.
The bleak but open landscape, moon-like in character, together with
the wispy trees and the figures gazing aimlessly at their own images
in the still water, produce a timeless sense of abstract beauty
resulting in a deep feeling of peace. It is this timeless sensation of
immutability that characterizes Burne-Jones' work.*

PLATE 32 far right
The Golden Stairs (1880)
Edward Coley Burne-Jones
Oil on canvas, 110 x 46 inches (279 x 117cm)

*There appears to have been no specific reference in the title to any
source but seems primarily to be an opportunity to construct a
charming image of a crowd of attractive young women on a staircase*

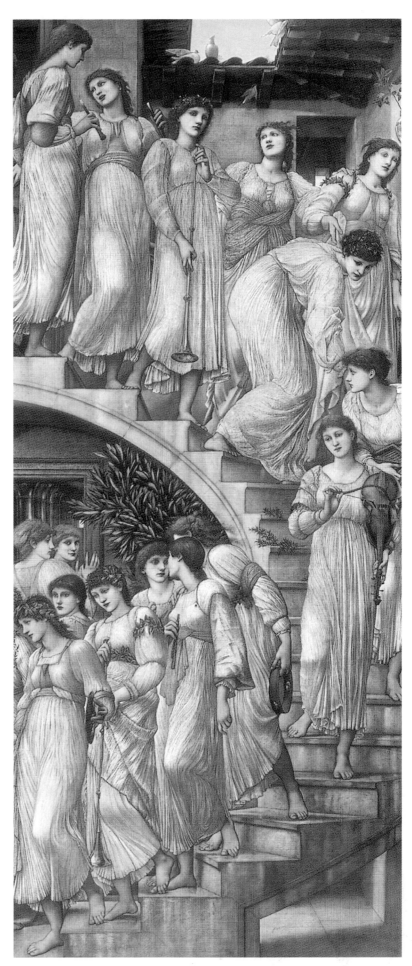

which enables the painter to give each figure almost equal weight and importance. It is the last of a small number of what have been called 'subjectless' compositions. A member of the Brotherhood, Frederic George Stephens, commented in a review that the female forms 'troop past like figures in an enchanted dream, each moving gracefully, freely, and in unison with their neighbours'.

PLATE 33 opposite
April Love (1856)
Arthur Hughes
Oil on canvas, 35 x 19¹/2 inches (88.9 x 49.5cm)

Hughes exhibited first in the Royal Academy in 1849, by which time he had become interested in the Pre-Raphaelite movement through reading The Germ *and had exhibited his first Pre-Raphaelite work,* Ophelia *(above), in 1852.* April Love *is his most famous work and its inspiration is to be found in the extract from Tennyson's 'The Miller's Daughter' which accompanied the painting in the 1856 Royal Academy.*

Love is hurt with jar and fret.
Love is made a vague regret.
Eyes with idle tears are wet.
Idle habit links us yet.
What is love? for we forget:
 Ah, no! no!

 The painting is not, however, a direct translation of Tennyson's poem but does express the pain of separation caused by a lovers' quarrel. Hughes was married in 1855 to Tryphena Foord who, after his first model withdrew, became the model for the girl; the dark figure in the background is believed to have been his friend, Alexander Munro, a sculptor with whom he shared a studio. The nostalgia and poignancy of this work made it a popular image of the age. It elicited enthusiasm from the influential Ruskin who called it 'exquisite in every way', while Madox Brown thought it 'very beautiful indeed'.

PLATE 34
Ophelia (1852)
Arthur Hughes
Oil on canvas, 27 x 48³/4 inches (68.6 x 123.8cm)

Love was a theme to which Hughes frequently returned and he has depicted Ophelia sitting beside the stream in which she will eventually drown. The eerie light and the steamy slime create a mood of poignant reflective misery as Ophelia contemplates Hamlet's rejection of her and her own death.

ARTHUR HUGHES (1830–1915)

Hughes was born in London where he lived and worked in an uneventful family situation free from the drama that accompanied most of the Brotherhood members. He was trained in the Royal Academy Schools after a period of study under Alfred Stevens at the Somerset House School of Design. Stevens was a versatile painter, designer and sculptor whose most famous work is the Wellington Monument in St. Paul's Cathedral, London (1856–75). After an undistinguished start, Hughes joined the Pre-Raphaelites in 1850 (according to him as a result of reading *The Germ*) and the characteristic work by which he is recognized began. His best work appeared in the 1850s and early '60s. He was not a powerful spirit but he remains one of the important figures in expressing the pictorial possibilities of Pre-Raphaelitism. Unquestionably his most famous painting is *April Love* (plate 33).

PLATE 35
Home from the Sea (1863)
Arthur Hughes
Oil on canvas, 20 x 25³/4 inches (51 x 65cm)

This painting is infused with a sentimentality which is a recurrent feature of Victorian painting and which a more pragmatic age finds somewhat repellent. When this is combined with a narrative message, as is this work, the painting may read like a romantic short story. Here the young sailor, home from the sea to find his mother dead and buried, falls on her grave watched by a sister dressed in mourning clothes. The sharp contrast of the carefully painted and effectively sunlit background landscape emphasizes the dark shadow in which the boy lies and provides an alternative delight in the continuance of life in nature. The model for the sister was Hughes' wife, as he said, she 'was still young enough ... and I think it was like'. The location for the painting has been identified by Hughes as the Old Church at Chingford in Essex, England.

PLATE 36 right
The Irish Vagrants (1853)
Walter Howell Deverell
Oil on canvas, 24¹/2 x 29⁵/8 inches (62.2 x 75cm)

In the middle years of the 19th century there was a prevailing taste in literary circles, exemplified in Dickens, to examine the life of the poor and disadvantaged, the friendless and lawless, the idle and unemployable. It was also of interest to consider the emigration/immigration problem. Deverell's painting touches on all these matters. The Irish labourers, itinerant and unemployed, lie or sit in front of a typical piece of English countryside while their children beg from the figures on horseback passing disdainfully and unconcernedly by. It is not a particularly distinguished work but the head of the woman in the centre foreground and the pensive figure reclining on the right are well-observed and delineated. The painting was never finished and although possibly submitted to the Royal Academy exhibition of 1853, was apparently not accepted. An X-ray photograph suggests that the figures on horseback were later additions.

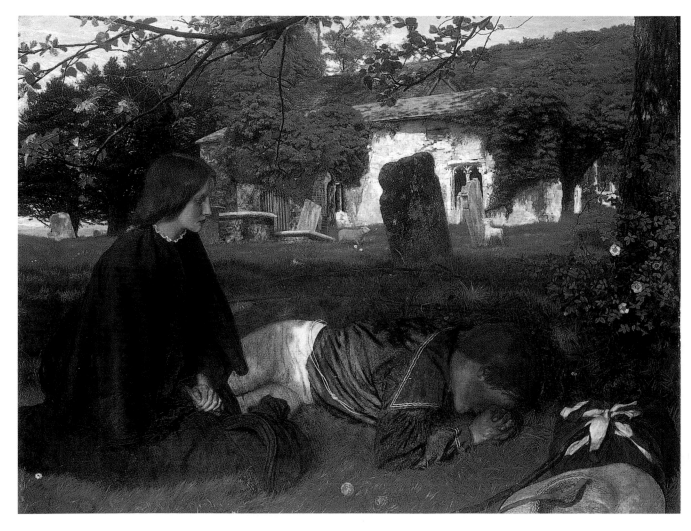

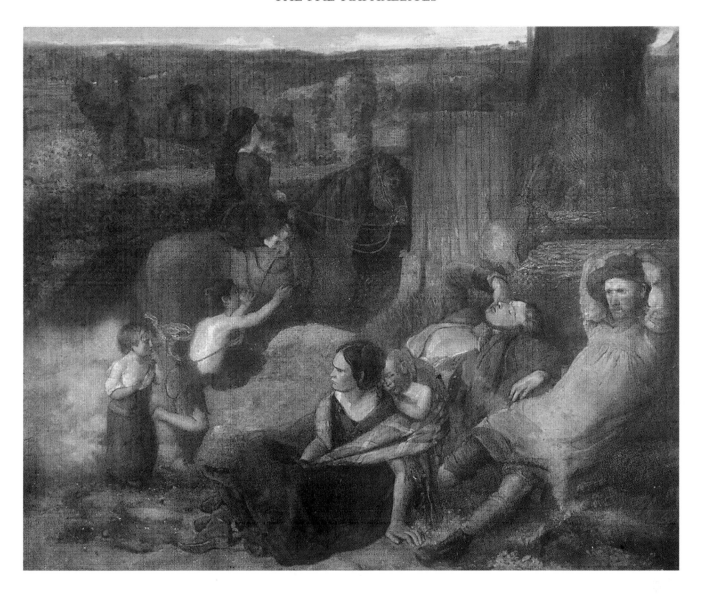

WALTER HOWELL DEVERELL (1827–1854)

In his short and tragic life, Deverell was always closely associated with the Brotherhood. Born in America a few years before Millais and trained at Sass's Academy like Rossetti, his intimate friend, he was proposed for membership just at the time that the Brotherhood was breaking up. For a short time he shared a studio in Red Lion Square, London with Rossetti (later taken by Burne-Jones and Morris). His effective working career lasted no longer than five years and his reputation has suffered undeserved neglect as a result. His father died in 1853 and although he was already in the later stages of a fatal disease himself, he was obliged to support his family and was working on two last paintings when he died at the age of 27. He was much-liked, spoken of with affection, and noted for his extraordinary good looks and charm. His best known contribution to the movement was his discovery of Elizabeth Siddal in a bonnet shop near Leicester Square!

He was appointed Assistant Master at the Government School of Design at the age of 21 and his work and influence were important during this short period. It is suggested that had he lived he might have contributed more to the development of the later stages of Pre-Raphaelitism than even Millais. He best known work is *The Pet*.

WILLIAM DYCE (1806–1864)

As a young painter studying in Rome in the 1820s, Dyce came in contact with the German Nazarene Group, who worked there and were opposed to the current classicism in Austria and Germany, producing work influenced by the linear styles of Perugino and Raphael. They were subsequently to have an influence on the Pre-Raphaelites. Dyce produced mainly religious subjects in a similar, highly finished, carefully worked technique; but his best known work is the meticulous study of Pegwell Bay, Kent (plate 37).

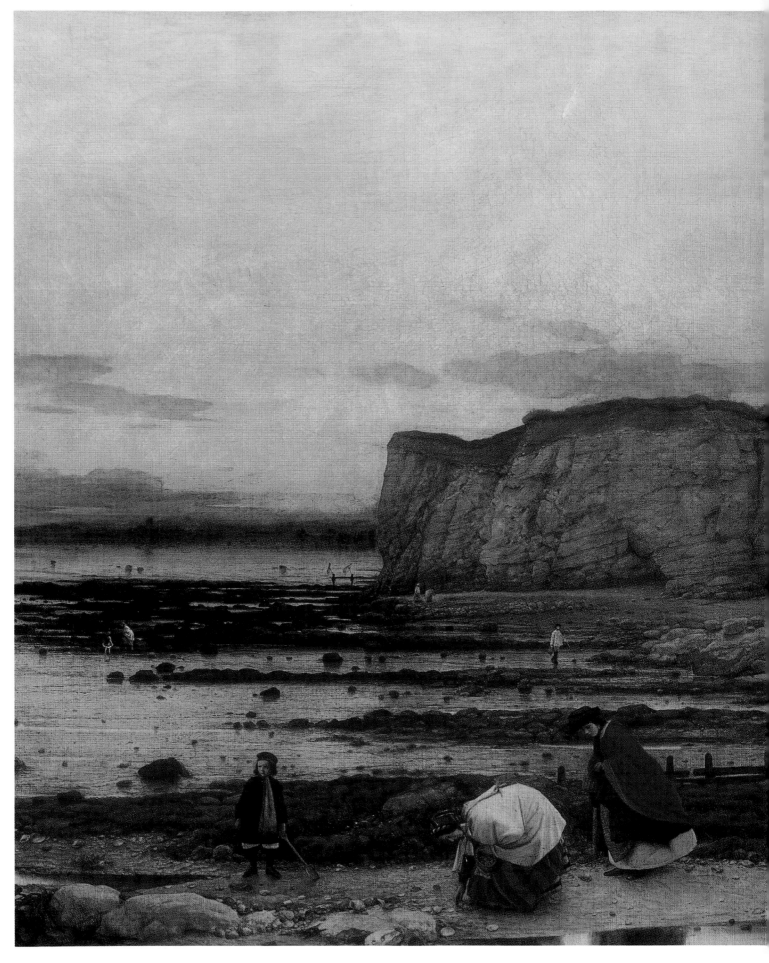

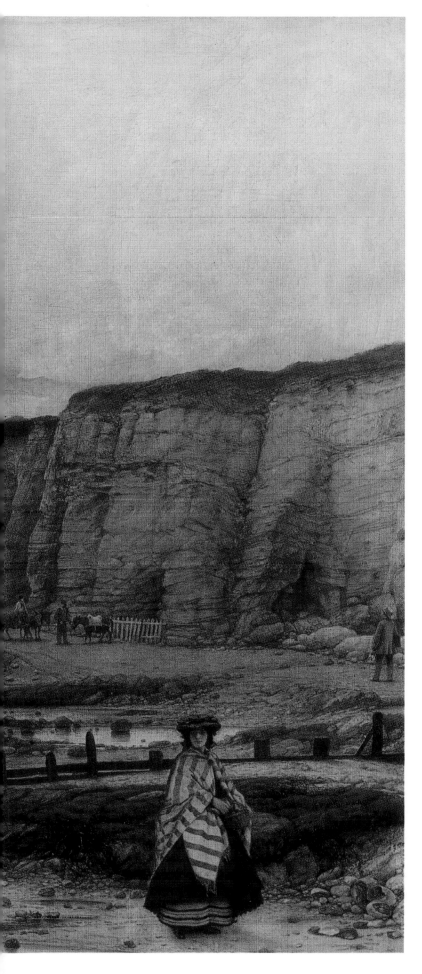

PLATE 37

Pegwell Bay, Kent: A Recollection of October 5th, 1858 (1858-1860)
William Dyce (1806–1864)
Oil on canvas, 24³/4 x 35 inches (62.9 x 88.9cm)

Dyce's best-known work, this meticulously detailed but compositionally integrated painting is a masterful work and one of the most admired of all Victorian landscapes. Pegwell Bay lies on the south coast of England and Dyce stayed there with his family in the autumn of 1858. He has portrayed himself near the right-hand edge, carrying sketching equipment, while his wife stands alone in the centre right foreground; the other two women are her sisters and one of her sons stands nearby. Dyce's particular accomplishment in this work is to have achieved a Pre-Raphaelite literality without losing the pictorial unity of the scene in its detail. The discernible comet at the centre top is Donati's, which appeared in 1858 and confirms Dyce's awareness of astronomical matters — he was a keen amateur scientist.

JOHN BRETT A.R.A. (1830–1902)

John Ruskin is closely allied in the public mind with the Pre-Raphaelites, and he certainly supported them in written and, on occasion, in verbal form. It was his habit to review exhibitions where their work was shown and he was generally well disposed towards it. His eruption into John Brett's life was, however, a critical disaster which led to Brett's failure to live up to his earlier promise.

Brett entered the Royal Academy Schools in 1854 and shortly afterwards became subject to Pre-Raphaelite influences, exhibiting in the 1857 Pre-Raphaelite Exhibition. His first work, which was much-admired in the exhibition, was *The Stonebreaker*, (plate 39), a scene set at Box Hill, near Dorking in Surrey, which he followed with a view of the Val d'Aosta in 1859, much influenced by the writings of Ruskin. While working on the painting, Brett was summoned by Ruskin, then in Turin, and given a lecture on what his future work should be. His observations and subsequent strictures in print seem to have broken Brett's spirit and his later work, mainly of seashore or marine subjects, failed to retain the same quality.

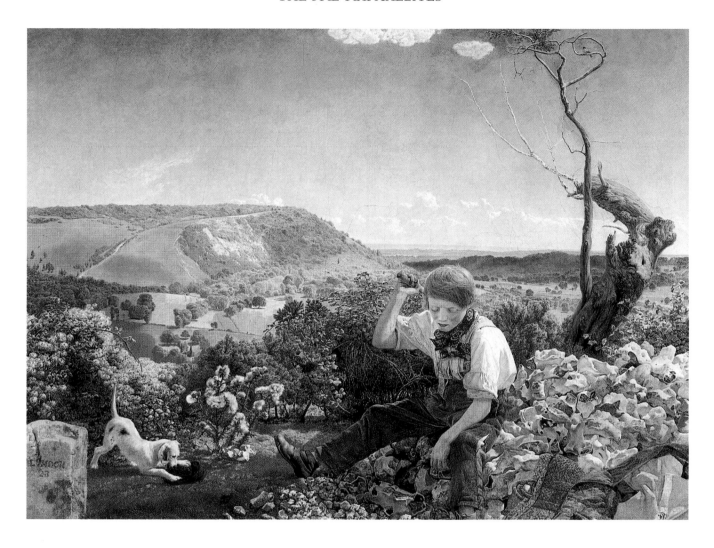

PLATE 38 opposite
Titian's First Essay in Colour (1856–57)
William Dyce (1806–1864)
Oil on canvas, 36 x 27¹/2 inches (91 x 70cm)

Although of an earlier generation, Dyce much admired the Pre-Raphaelites and was a friend of Ruskin and an admirer of his writings. In the 1850 Royal Academy exhibition, it was Dyce who took Ruskin to see Millais' Christ in the House of His Parents *(plate 17), thus initiating important developments in the history of Pre-Raphaelitism. He was also an admirer of the Nazarenes and visited Italy as a young man. The qualities of his treatment of visual details are his main characteristic and they are nowhere better seen than in this astonishingly meticulous work which depicts the young Titian adding colour to a drawing of the Madonna with the juices of the flowers he holds.*

PLATE 39 above
The Stonebreaker (1857)
John Brett (1830–1902)
Oil on canvas, 19¹/2 x 26¹/2 inches (49.5 x 67.3cm)

When this painting was first exhibited in the 1858 Royal Academy exhibition, Ruskin eulogized the work and described it as 'simply the most perfect piece of painting with respect to touch in the Academy this year'. He decided to take Brett under his wing, which turned out to be a not altogether successful relationship and Ruskin subsequently criticized Brett's work. Although not distinguished with the same quality of detail to be found in Dyce, the work is full of incident and a strong, if unidentifiable sense of light. It is also a little suspect in the treatment of middle-distance aerial perspective. Nevertheless, it is Ruskinian in intent.

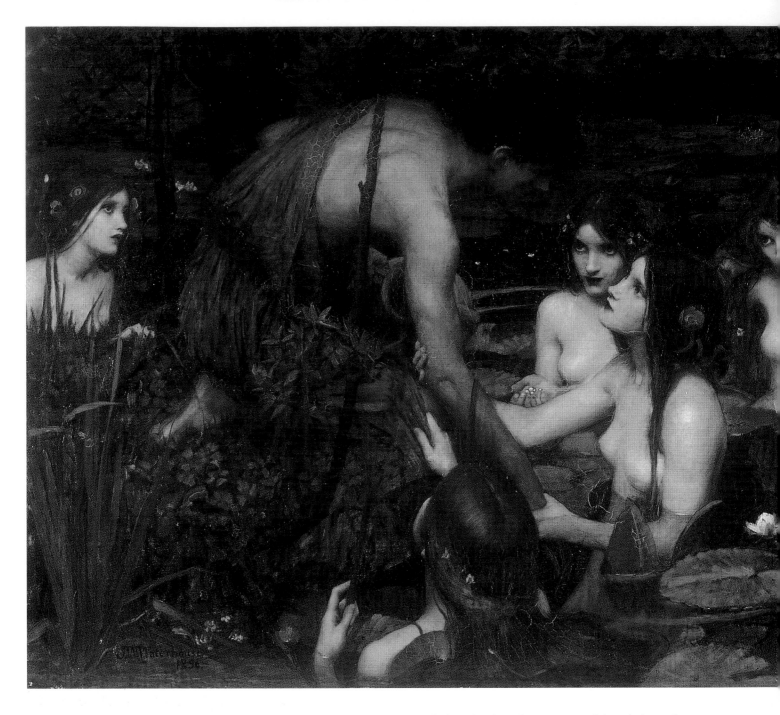

PLATE 40
Hylas and the Water Nymphs (1896)
John William Waterhouse
Oil on canvas, 38⁷/₈ x 64¹/₄ inches (98.2 x 163cm)

The classical sources, particularly the Homeric legends, were another inspiration during the 19th century and this painting illustrates the story of Hylas, the much-loved squire of Heracles, one of the Argonauts, who having gone to fetch water from the nearby pool of Pegae had not returned. When Heracles sent searchers, all they discovered was the water pitcher, because Dryope and her sister water nymphs had fallen in love with Hylas and had enticed him into their Pegaean underwater grotto. The visual conviction of the scene, not the least the physical attractiveness of the naked nymphs, made this painting Waterhouse's most admired work which has also come to be regarded as a prime example of the use of classical subject-matter to release some of the publicly-suppressed sexuality of the age, in which the notion of the femme fatale played a central role. Waterhouse's own career was one of utmost success and respectability and he and his wife lived a quiet and uneventful life in London's St. John's Wood.

PLATE 41 below
Ophelia (1910)
John William Waterhouse
Oil on canvas, 40 x 24 inches (101.6 x 61cm)

Waterhouse, like other PRB-associated painters, used Shakespeare as a subject source and this painting, although not as dramatically effective as Millais' work, nevertheless shows Waterhouse's fluency and technical mastery. He has managed to suggest the other-worldly, near-madness of Ophelia's last days as she sits by the side of the stream which will be the cause of her death, braiding her hair and doubtless softly singing her well known dirge.

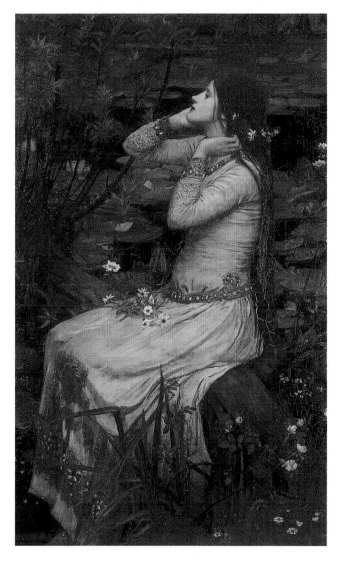

JOHN WILLIAM WATERHOUSE (1849–1917)

Perhaps the most brilliant of the later painters of Victorian romanticism associated with the Pre-Raphaelites, Waterhouse painted subjects mainly taken from classical sources but his association with the later stages of the movement can be identified through his treatment of subjects taken from Tennyson and Keats. His best known and most bravura work is *The Lady of Shalott* (plate 42) although his Ophelia (Shakespeare), right, and *La Belle Dame Sans Merci* (Keats) are fine examples of late Victorian romanticism. His *Hylas and the Water Nymphs* (plate 40), with its delicate eroticism, is a good example of his effective treatment of the Greek myths. Waterhouse, who was born in Rome of artist parents and lived his early years in Italy, was like other late Pre-Raphaelite figures and lived a quiet family life in St. John's Wood, London, not searching for artistic honours or being tempted by the nymphs he portrayed. He became an associate of the Royal Academy in 1885 and a full Academician in 1895.

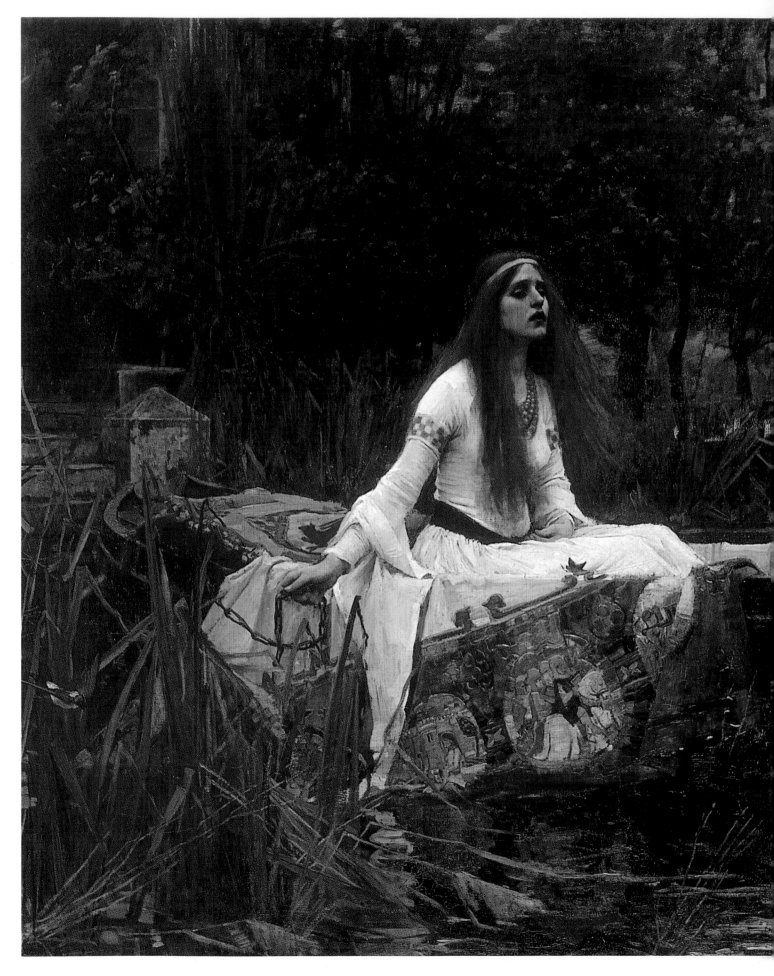

PLATE 42
The Lady of Shalott (1888)
John William Waterhouse (1849–1917)
Oil on canvas, 60 1/4 x 78 3/4 inches (153 x 200cm)

Although Waterhouse was not born when the Brotherhood was formed, his work in the later Victorian period is the finest influenced by the Pre-Raphaelites at that late period. It is clearly Pre-Raphaelite in both subject-matter and technique and illustrates the difficulty that any consideration of its limits presents. This large work is the first of a number in the style and three of the subject that Waterhouse painted. Tennyson's Idylls of the King, as has been mentioned, was a favourite source and the Lady of Shalott one frequently chosen. It has been suggested that Waterhouse may have been first attracted to the movement style by a visit he made to Millais' 1886 exhibition at the Grosvenor Gallery, London.

WILLIAM MORRIS (1834–1896)

Although William Morris was not a Pre-Raphaelite, either in spirit or in his work, he was a friend and associate of most of them and one of the most important creative influences in later Victorian artistic culture. It would be inappropriate to examine his full career here, but he was in sympathy with the Pre-Raphaelite interest in early history, a friend and follower of Ruskin and, through the company he formed, a patron of a number of members of the Pre-Raphaelite circle, notably commissioning Burne-Jones' designs for stained glass and his illustrations for Morris' Kelmscott Press edition of Chaucer.

WILLIAM SHAKESPEARE BURTON (1824–1916)

The son of an actor, Burton was born in London and studied at the Government School of Design and the Royal Academy Schools. A sensitive artist who suffered much from adverse criticism which contributed to later breakdowns in health and eventually almost an abandonment of painting, his reputation was made by the painting *The Wounded Cavalier* (plate 44) and much admired when exhibited in the R.A. exhibition of 1856. When, by the 1890s, his public reputation had albeit disappeared, the painting was rediscovered by critics and his abilities recognized. He was twice-married, moved to Italy in 1868 and remained there for eight years until the death of his mother.

PLATE 43

La Belle Iseult or **Queen Guinevere** (1858)
William Morris (1834–1896)
Oil on canvas, 28^1/$_2$ x 20 inches (72.3 x 50.8cm)

Morris's talents and interests were directed to more practical and commercially effective ends through most of his career; but under the influence of Rossetti he became involved with the Oxford murals and at the time met Jane Burden, who became the model for this painting. It is the only known finished oil painting by him. She was known and admired by the Pre-Raphaelites who described her, as they did all the women they considered beautiful in their youthful enthusiasm, as a 'stunner', and in the following year Morris married her. It portrays Queen Guinevere, wife of King Arthur and lover of Sir Lancelot, which was consequently a favourite subject of the movement. The painting does not show a great natural painting talent but it does encapsulate something of the spirit of Pre-Raphaelitism.

PLATE 44

The Wounded Cavalier (1856)
William Shakespeare Burton (1824–1916)
Oil on canvas, 35 x 41 inches (89 x 104cm)

Although this is Burton's only Pre-Raphaelite painting, it caused a sensation when it was first exhibited in the 1856 Royal Academy show for its extraordinary attention to detail in the Ruskinian manner. As did Monet when later painting his Women in the Garden, *Burton is reported to have dug a hole for himself and his easel so that he could more closely observe and paint the ferns and other details of the foreground of this work. The painting depicts a wounded cavalier, the colour drained from his face, being tended by a Puritan girl while her lover in Puritan garb stands jealously watching, clutching a large Bible. One of the more intriguing details is the Red Admiral butterfly on the broken sword-blade lodged in the tree.*

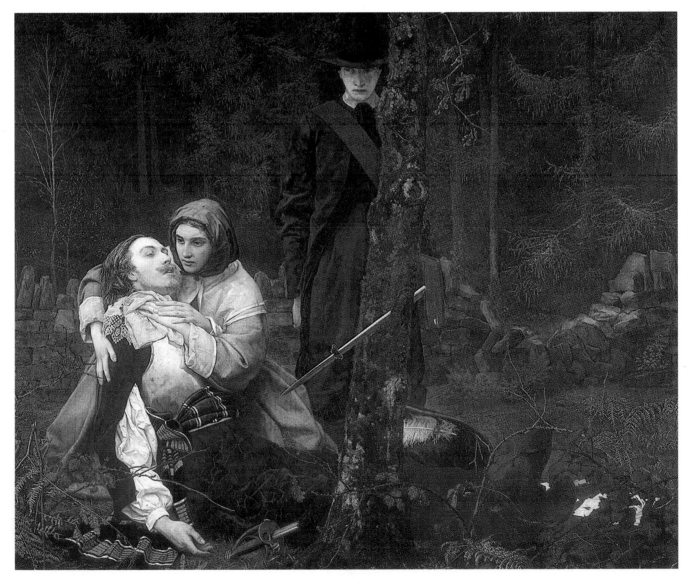

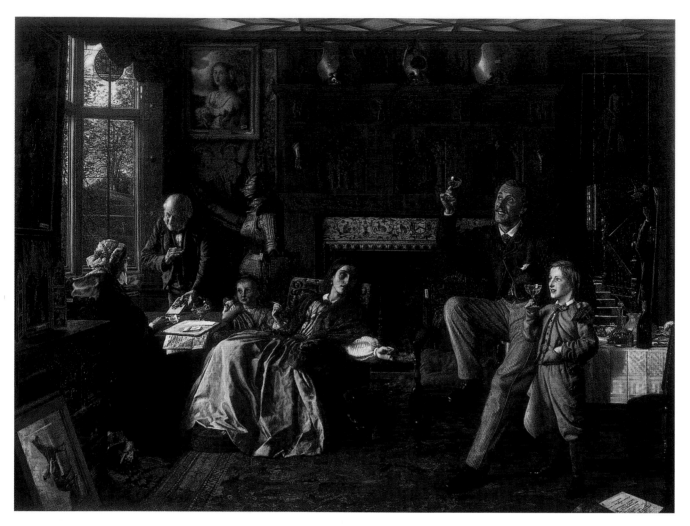

ROBERT BRAITHWAITE MARTINEAU (1826–1869)

Martineau's early death at the age of 43 ended a highly promising career. He is best known for the narrative painting *The Last Day in the Old Home* (above) in which all the elements combine to build a poignant romantic novelist image. For some time Martineau shared a studio with Holman Hunt who was his teacher.

THOMAS SEDDON (1821–1856)

Seddon's father, as a cabinetmaker, expected his son to follow this career so, at the age of 14, he joined his father's business, going to Paris to study ornamental design. However, he wished to become a painter and studied art in a drawing school while at the same time winning a silver medal in 1848 for the design of a sideboard. His recovery from a serious attack of rheumatic fever resulted in his devotion to a 'practical Christianity' and a visit to the East in 1853 which lasted for a year, during which he painted for a time with Holman Hunt and produced his most important work in a small *oeuvre*, the *Valley of Jehoshaphat* (plate 46). He visited Egypt in 1856 and while there died in Cairo of dysentery.

PLATE 45

The Last Day in the Old Home (1862)

Robert Braithwaite Martineau

Oil on canvas, 41^1/$_2$ x 56^1/$_2$ inches (105.4 x 143.5cm)

This detailed, anecdotal genre painting, although not possessing the distinction of drawing which was achieved even by other minor figures, is nevertheless full of significant elements, each carrying information which fills out the central message of the young irresponsible aristocrat who has gambled away his inheritance on the horses (see bottom left) and has been obliged to sell up (see sale catalogue bottom right). On the left, the old mother is paying off the faithful retainer while the son is drinking with his father, indicating that he will develop into a man of similar character. The sadness of the scene is concentrated in the figure of the wife who gazes resignedly at her husband and son. Such social documents were a feature of Victorian painting and go back to the Hogarthian moralist series.

PLATE 46

Jerusalem and the Valley of Jehoshaphat from the Hill of Evil Counsel (1854)

Thomas Seddon

Oil on canvas, 25 x 32 inches (63.5 x 81.2cm)

Hunt spent some time with Thomas Seddon on his 1853-54 visit to the Holy Land and while there Seddon produced this painting, his best-known in a small oeuvre *since he died of dysentery in Cairo at the age of 35 in 1856. The painting is highly detailed in the Pre-Raphaelite method but Seddon's attempt to paint the landscape in full sunlight led him to a garish intensity of colour, particularly his use of deep purples in the shadows, which indicate his lack of the accomplishments that made Holman Hunt a greater painter. Seddon's attention to detail, effective presentation of spatial relationships and careful perspective do, however, make this painting a significant example of the Pre-Raphaelite method and technique although he was never a member of the group.*

JOHN WILLIAM INCHBOLD (1830–1888)

Born in Leeds, Inchbold was one of the northern English Liverpool–Leeds group whose work was collected by the growing group of northern-based industrialists responsible for increasing British wealth and power. Newly rich, they aspired to culture and found the meticulous attention to detail in PRB paintings most attractive. Inchbold, like Brett and Windus, was subject to the praise and opprobrium of Ruskin's sharp, all-powerful tongue and like them suffered. But unlike Windus he continued to paint, visiting a number of countries including Spain, and made an influential visit to Venice; but some of his most effective work was painted in Devon and Cornwall. He appears, however, to have been of a somewhat morose temperament and this, together with long-lasting financial difficulties and Ruskin's input, resulted in a later deterioration of his work.

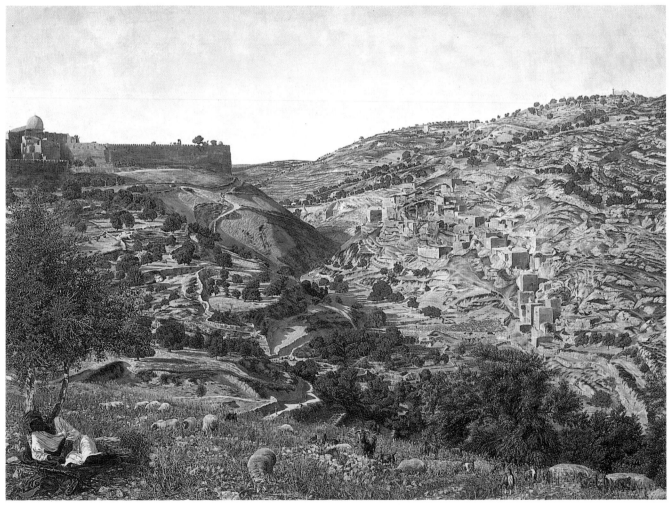

PLATE 47

Study in March ('In Early Spring') c.1855
John William Inchbold (1830–1888)
Oil on canvas, 20 x 13¹/2 inches (51 x 34cm)

*Inchbold first exhibited a painting at the 1852 Royal Academy
show and he is supposed to have studied in the Royal Academy
schools although he does not appear in the records. He was a mild-
mannered man, born in Leeds in the north of England and made
the acquaintance of Ruskin in about 1854 – unfortunately for him
– since Ruskin could be influential when supporting his own
enthusiasms but brutally dismissive when he discerned, correctly or
incorrectly, any inadequacy in a painter. Initially, in his Academy
notes, Ruskin praised Inchbold; but in 1858 while Inchbold was
painting in Switzerland at Ruskin's suggestion, they met and as
Ruskin's criticism asserts, 'At last I think I made him thoroughly
uncomfortable and ashamed of himself, and then I left him.' Not a
sympathetic observation, and Ruskin left Inchbold a thoughtful and
unhappy man. This painting, often known as 'In Early Spring', is
typical of his early Pre-Raphaelite work, with its great attention to
foreground detail. The painting was accompanied in the exhibition
by a Wordsworth quotation: 'When the primrose flower peeped
forth to give an earnest of the spring.'*

PLATE 48

Burd Helen (1856)
William Lindsay Windus (1823–1907)
Oil on canvas, 33¹/4 x 26¹/4 inches (84.4 x 66.6cm)

*Another victim of Ruskin's powerful influence, Windus was first
praised by him for this painting which depicts a scene from an old
Scottish ballad of the girl, Burd Helen, whose story is told in the
catalogue entry for the 1856 Royal Academy exhibition:*
Helen fearing her lover's desertion, runs by the side of his
horse as his foot page
Lord John he rode, Burd Helen ran,
a live-lang simmer's day;
Until they cam' to Clyde water,
Was filled frae bank to brae.

Seest thou yon water, Helen, said he,
That flows from bank to brim?
I trust to God, Lord John, she said,
You ne'er will see me swim.
*The ballad ends with her bearing him a child, and finally their
marriage with full ceremony. Unfortunately for Windus, his next
work, Too Late, was strongly criticized by Ruskin, which so
depressed Windus that he effectively gave up painting permanently.*

PLATE 49
Dante and Beatrice (1883)
Henry Holiday
Oil on canvas, 55 x 78¹/2 inches (140 x 199cm)

The story of Dante's meeting with Beatrice on a bank of the Arno in Florence became a well known story in Victorian times and was the subject of a number of paintings, the most famous of which, and used widely in history books, is this one by Holiday who was mainly a designer of stained glass and teacher. It carries some of the characteristics of the Pre-Raphaelites, the Rossetti family's passion for Dante and his works having created an interest in the poet's life and works.

WILLIAM LINDSAY WINDUS (1823–1907)

Windus was a Liverpool artist whose potential career was largely demolished by Ruskin's influence. After praising him for *Burd Helen* (plate 48), Ruskin heavily criticized his next major painting, attacking it as morbid an indeterminate with the result that, following his wife's death soon after, he destroyed most of his paintings and abandoned his career. It is a reflection of the inordinate influence that Ruskin had acquired before he was 40.

HENRY HOLIDAY (1839–1927)

As a young man, Holiday was a friend of Burne-Jones and Rossetti and under their influence produced the few paintings he undertook. His best known work is reproduced above and has become a well known and frequently used illustration of the meeting of Dante with Beatrice, who became the love of his life. It is an example of the illustrative character of much late-PRB influence, as well as emphasizing the medieval source and the importance of Dante.

HENRY WALLIS (1830–1916)

Wallis was born in London and in 1848 was admitted to the Royal Academy Schools as a probationer. It also appears, although the dates are uncertain, that he studied in Gleyre's atelier in Paris in the 1850s. (It was at Gleyre's that some of the putative Impressionists later met.) When his stepfather died in 1859, Wallis inherited a number of properties which enabled him to paint without having to rely on sales and to travel widely in the near East, Italy and Sicily. He died in Croyden in 1916, during the First World War. His most notable painting is *The Death of Chatterton* below.

THE LEGACY OF THE PRE-RAPHAELITES

There are many late-Victorian painters who were influenced by the Pre-Raphaelite revolution: indeed, it might be claimed that to some degree at least, few escaped. In consequence, the impact of the Brotherhood on British painting was much longer-lasting than the movement itself and it is a matter of artistic archaeology to identify Pre-Raphaelite influences in most works. Other later influences (such as the so-called Aesthetic Movement at the turn of the century) may dominate, but the Brotherhood was a pervasive force to the extent that it is difficult to draw the line of exclusion. The reader will not therefore, I hope, imagine that the work of the artists considered here is in any way intended as exhaustive.

However, it was in 19th-century art that an early element in the destruction of what had become an intellectualist, élitist and moribund self-congratulatory and introspective artistic scene, controlled by the Establishment academies, occurred. In this, it became the first effective move towards an art of the future given, of course, an even more powerful impetus by the Impressionist and Post-Impressionist movements which succeeded it in France.

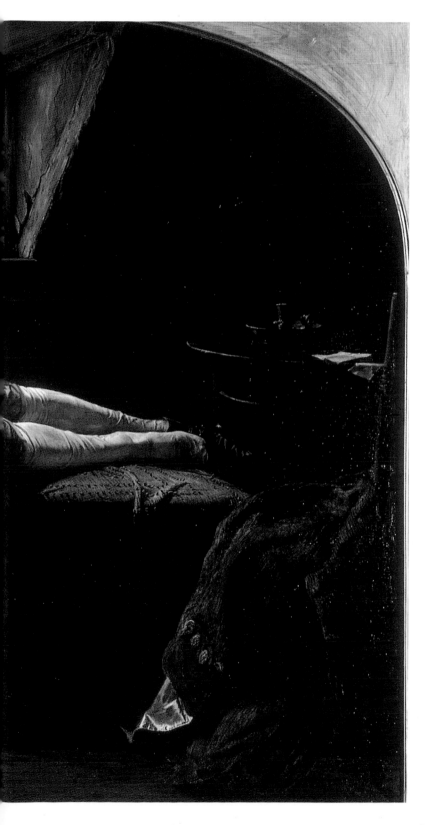

PLATE 50

The Death of Chatterton (1856)
Henry Wallis
Oil on canvas, 23³/4 x 35³/4 inches (60.3 x 90.8cm)

The tragic death by suicide of the brilliant young poet Thomas Chatterton at the age of 18, in extreme poverty by arsenic, is the subject of this painting. Chatterton's public reputation rests, however, on the extraordinary story of the documents which he claimed to be by a 15th-century monk, Thomas Rowley: these were revealed to be as fictitious as the writings which had been concocted by Chatterton himself. His own poems were anticipatory of the Romantic movement and influenced two such diverse geniuses as Wordsworth and Blake. Exhibited at the Royal Academy in 1856, the painting carried a quotation from Christopher Marlowe:

Cut is the branch that might have grown full straight
And burned is Apollo's laurel bough.

The work is dramatically effective and painted with the characteristic Pre-Raphaelite detail, the usual search for accuracy causing the painting to be executed in the attic in Gray's Inn in which Chatterton had committed suicide. The model was the novelist George Meredith, at the time aged about 28, ten years older than Chatterton was at the time of his death. Wallis was a friend of Meredith and two years after the painting he eloped with Meredith's wife, the daughter of another famous novelist, Thomas Love Peacock.

PAGES 6-7
A Dream of the Past –
Sir Isumbras at the Ford
National Museums and Galleries of Merseyside
PLATE 1
Beata Beatrix
The Tate Gallery, London
PLATE 2
The Hireling Shepherd
Manchester City Art Galleries
PLATE 3
Autumn Leaves
Manchester City Art Galleries
PLATE 4
Jesus Washing Peter's Feet (Christ Washing Peter's Feet)
The Tate Gallery, London
PLATE 5
Our English Coasts ('Strayed Sheep')
The Tate Gallery, London
PLATE 6
Isabella and the Pot of Basil
Tyne and Wear Museums: Laing Art Gallery, Newcastle upon Tyne
PLATE 7
Monna Vanna
The Tate Gallery, London
PLATE 8
John Ruskin at Glenfinlas
The Tate Gallery, London
PLATE 9
The Order of Release 1746
The Tate Gallery, London
PLATE 10
Mariana
Makins Collection/Bridgeman Art Library, London
PLATE 11
The Shadow of Death
Manchester City Art Galleries
PLATE 12
Valentine Rescuing Silvia from Proteus
Birmingham Museums and Art Gallery/Fine Art Picture Library
PLATE 13
The Light of the World
Keble College, Oxford
PLATE 14
The Scapegoat
National Museums & Galleries of Merseyside
PLATE 15
The Awakening Conscience
The Tate Gallery, London
PLATE 16
Lorenzo and Isabella (Isabella)
The Tate Gallery, London
PLATE 17
Christ in the House of His Parents (The Carpenter's Shop)
The Tate Gallery, London
PLATE 18
The Blind Girl
Birmingham Museum and Art Gallery
PLATE 19
Bubbles (Poster for Pear's Soap)
Fine Art Picture Library
PLATE 20
Ophelia
The Tate Gallery, London

PLATE 21
The Girlhood of Mary Virgin
The Tate Gallery, London
PLATE 22
Ecce Ancilla Domini (The Annunciation)
The Tate Gallery, London
PLATE 23
The Wedding of St. George and the Princess Sabra
The Tate Gallery, London
PLATE 24
The Renunciation of Queen Elizabeth of Hungary
Johannesburg Art Gallery
PLATE 25
Mother and Child
The Tate Gallery, London
PLATE 26
The Last of England
The Tate Gallery, London
PLATE 27
Work
Manchester City Art Galleries
LATE 28
Panel from The Briar Rose: The Sleeping Beauty
Faringdon Collection, Buscot Park, Faringdon/Fine Art Picture Library, London
PLATE 29
King Cophetua and the Beggar Maid
The Tate Gallery, London
PLATE 30
The Beguiling of Merlin
National Museums & Galleries of Merseyside
PLATE 31
The Mirror of Venus
Calouste Gulbenkian Foundation, Lisbon/ Fine Art Picture Library, London
PLATE 32
The Golden Stairs
The Tate Gallery, London
PLATE 33
April Love
The Tate Gallery, London
PLATE 34
Ophelia
Manchester City Art Galleries
PLATE 35
Home from the Sea
Ashmolean Museum, Oxford
PLATE 36
The Irish Vagrants
Johannesburg Art Gallery
PLATE 37
Pegwell Bay, Kent: A Recollection of October 5th, 1858
The Tate Gallery, London
PLATE 38
Titian's First Essay in Colour
Aberdeen Art Gallery
PLATE 39
The Stonebreaker
National Museums & Galleries of Merseyside
PLATE 40
Hylas and the Water Nymphs
Manchester City Art Galleries
PLATE 41
Ophelia
Christie's, London

PLATE 42
The Lady of Shalott
The Tate Gallery, London
PLATE 43
La Belle Iseult or Queen Guinevere
The Tate Gallery, London
PLATE 44
The Wounded Cavalier
Guildhall Art Gallery, Corporation of London/Bridgeman Art Library
PLATE 45
The Last Day in the Old Home
The Tate Gallery, London
PLATE 46
Jerusalem and the Valley of Jehoshaphat from the Hill of Evil Counsel
The Tate Gallery, London
PLATE 47
Study in March ('In Early Spring')
Ashmolean Museum, Oxford
PLATE 48
Burd Helen
National Museums & Galleries of Merseyside
PLATE 49
Dante and Beatrice
National Museums & Galleries of Merseyside
PLATE 50
The Death of Chatterton
The Tate Gallery, London

Picture research – Image Select International Limited